EDVARD MUNCH

EDVARD MUNCH

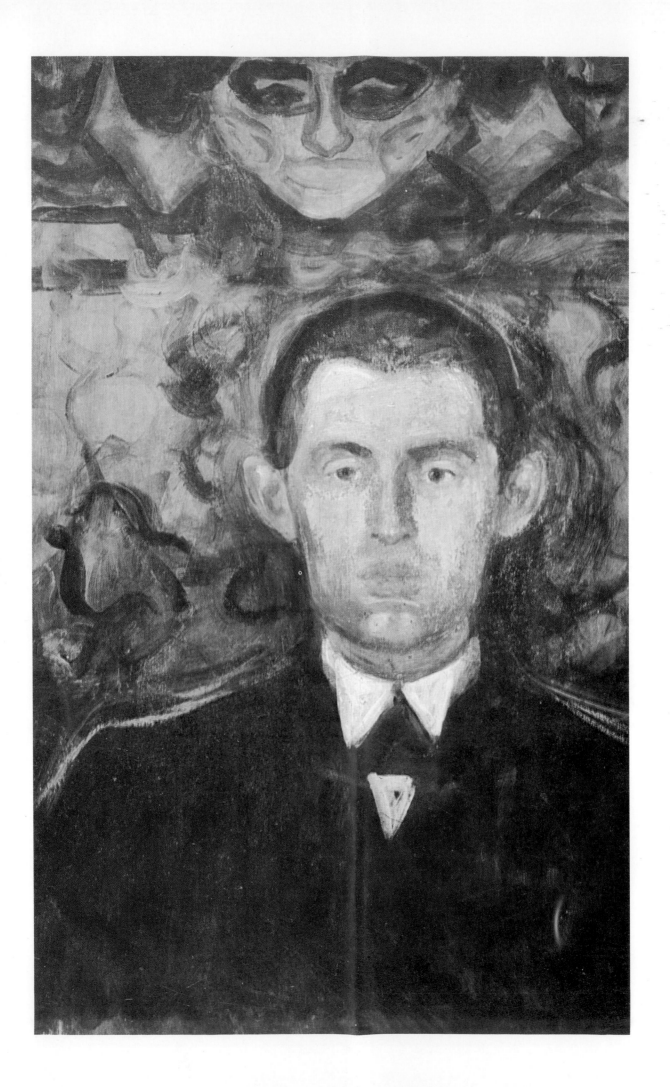

EDVARD

MUNCH

TEXT BY

THOMAS M. MESSER

Director, The Solomon R. Guggenheim Foundation, New York

HARRY N. ABRAMS, INC., *Publishers*

Frontispiece: SELF-PORTRAIT BENEATH THE MASK.
c. 1892. Oil on canvas, 27⅛ x 17⅛". Munch-museet, Oslo.
See page 39 for commentary

ISBN 0–8109–1415–8
Library of Congress Catalog Card Number: 85–71498

Printed and bound in Singapore

 Harry N. Abrams, Inc.
100 Fifth Avenue
New York, N.Y. 10011
www.abramsbooks.com

CONTENTS

ACKNOWLEDGMENTS

The first step toward this book was made in the early 1960s when I traveled through Norway and other European countries to select a retrospective exhibition of Edvard Munch's paintings that took place at the Guggenheim Museum in the fall of 1965. Material gathered for the publication of the accompanying catalogue—a task depending upon help from Norwegian museums and upon wide participation of the Guggenheim Museum's staff—served as the point of departure for subsequent concerns with Munch and his art. The descriptions of individual canvases took me back to the pictorial sources, involving me with museum directors, curators, collectors, and some surviving friends of the artist. Museum officials at Bergen's Rasmus Meyers Samlinger and the Bergen Billedgalleri, and in Oslo's Nasjonalgalleriet and the Munch-museet, generously made their facilities available and provided me with useful information. Jan Askeland, Dr. Sigurd Willoch, Leif Østby, Pal Hougan, Johan H. Langaard, and Reidar Revold and their respective institutions must be specially thanked. Most of the quotations from Munch's writings, as well as much of the information found in the Chronology, have been adapted from the publications of Messrs. Langaard and Revold. Mr. Revold read my manuscript in an early stage and made suggestions for which I am grateful but, at the same time, I do not wish to burden him with responsibility for possible shortcomings. The major part of the text was written in 1967 when, as a Senior Fellow at the Center for Advanced Studies at Wesleyan University, I was free to devote several months of undivided time to this project. Lastly, I am much indebted to Joan Vass for her careful editing and her uncommon grasp of the subject, and to Dr. Louise Averill Svensdsen for comparing color proofs with original works.

Edvard Munch's lithograph *Attachment* (fig. 1), dated 1896, shows two youthful profiles in obsessive dependence upon each other. They are tied up within a field of magnetic emotion defined by flowing feminine hair— Munch's ubiquitous symbol—that seems to be alive and grasping as it attempts to possess the male. An intense gaze unites and isolates those exchanging it. The magnified heads of the lovers are projected against a landscape that is indicated schematically through strips of land and sea, and penetrated by the rays of a celestial body, be it sun or moon. The same two intense faces had already been etched a year before in two near-identical prints titled *Lovers on the Beach* (figs. 2 and 3). Here their mute and tragic paleness creates a foreground image for a landscape predicated upon a huge inverted U-shape that has its literal origins in the single form created by the crowns of three linden trees. The trees still stand in Aasgaardstrand, a village at Oslo Fjord, and appear repeatedly in Munch's work from the early 1890s. In *Starry Night* (colorplate 15) tree and lovers reappear, although

the latter announce themselves merely as mysterious shadows, as if the painter knew about them but wished to keep their secret.

Near the turn of the century, Munch amplified the *Attachment* theme in his monumental *The Dance of Life* (colorplate 24), where the form of the merged lovers serves as the central image—as a symbol for mature, erotic love self-contained within its own intensity and oblivious to the world. The same moon or sun of the summer night that stood both as formal accent and as emblematic sign in the earlier print casts its powerfully attenuated mirror image into the sea. But *The Dance of Life* draws from other sources as well. The additional two feminine foreground figures, which now share in the central drama, have been transformed with appropriate modification from an often repeated canvas, which, in its most telling embodiment of 1895, is known as *Woman in Three Stages* (colorplate 20). In it, the feminine protagonists appear to symbolize, as in *The Dance of Life*, a triad of averted innocence, aggressive sexuality, and spent

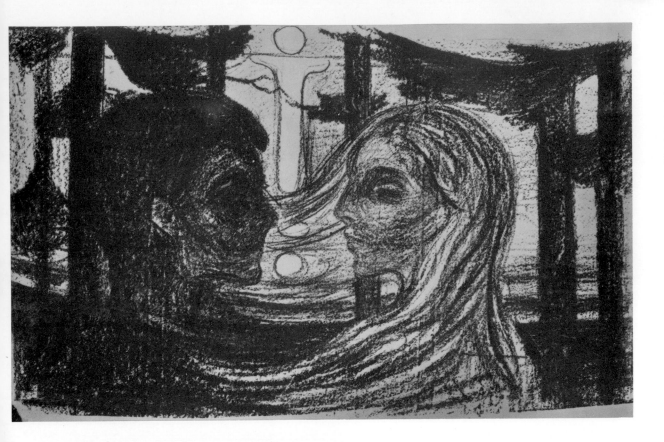

Figure 1.
ATTACHMENT (ATTRACTION).
1896.
Lithograph, $15\frac{1}{2} \times 24\frac{1}{2}''$.
(Sch. 66★)

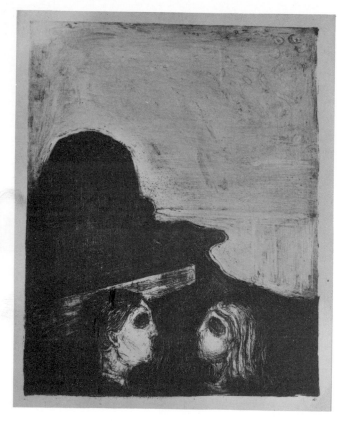

emotion. It is apparent from such a sequence that through deft modifications in scale, medium, imagery, and through corresponding formal adjustments, Munch deployed his themes to serve various ends.

The counterpart to *Attachment*—a lithograph exe-

★ Note: (Sch.) refers to the *catalogue raisonné* by Gustav Schiefler, who tried faithfully to catalogue all of Munch's prints through 1926.

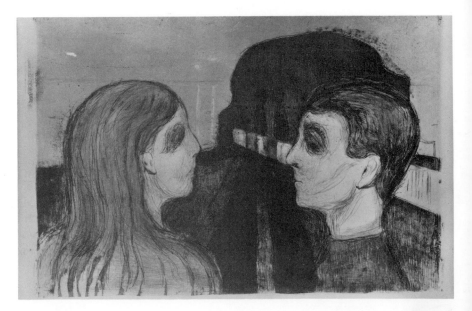

above: Figure 2.　LOVERS ON THE BEACH I. 1895.
Etching and drypoint, $12\frac{3}{8} \times 9\frac{1}{2}''$. (Sch. 17)

right: Figure 3.　LOVERS ON THE BEACH II. 1895. Etching, aquatint, drypoint, and roulette, $10\frac{1}{2} \times 13\frac{1}{2}''$. (Sch.18)

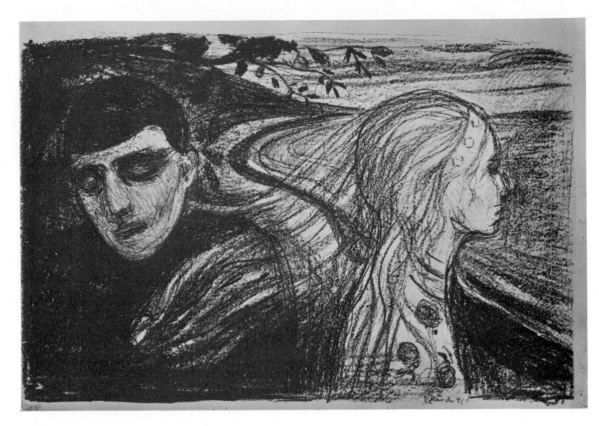

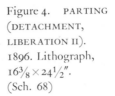

Figure 4. PARTING (DETACHMENT, LIBERATION II). 1896. Lithograph, 16⅜ × 24½". (Sch. 68)

cuted in the same year—is named *Parting* (fig. 4) or in its more literal translation *Detachment*. Here the suffering male (already known to us from *Woman in Three Stages*) is re-created as he struggles free from woman's grasp. An even closer model for the lithograph *Parting* may be found in an oil of the same name (fig. 5), which in turn is preparatory for *Woman in Three Stages*.

Relatedness to other works, whether close or distant, directly traceable or obliquely so, can be demonstrated in Munch's painted and printed oeuvre almost at will.

Links can be established through an identity of scenery, an overlapping or apposite symbolism, the reappearance of the same dramatis personae, and interchangeable forms and images. The works mentioned above create within themselves circles or ellipses that can be enlarged to comprise other similarly relatable examples until, through an ever extended inclusiveness, a grand design will encompass the totality of Munch's work to reveal a visual philosophy articulated in a creative life exceeding a half-century.

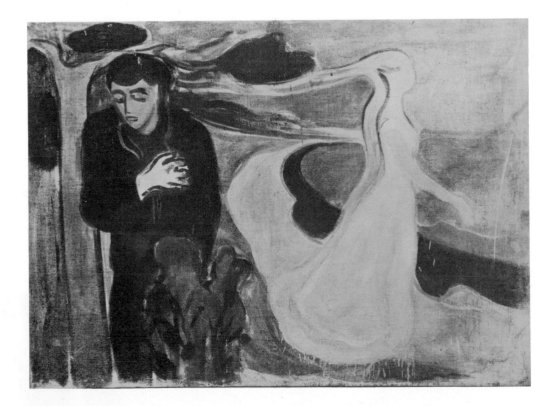

Figure 5. PARTING. 1894. Oil on canvas, 26⅜ × 50⅜". *Munch-museet, Oslo*

Edvard Munch is above all the painter of the *Frieze of Life*—a cycle of paintings and prints in which the joy and ecstasy, disquiet and anxiety, strains and tensions, and the psychic vibrations of modern man are brought to the surface through images, symbols, and forms that evoke something of the indivisibility of love, life, and death, the simultaneity of joy and pain, and the merely parabolic significance of the transitory human condition in the presence of the eternal rhythms of inanimate nature. The *Frieze* grew out of the Norwegian's deep commitment to significant content and his impatience with art as a conventional language. "We should stop painting interiors with people reading and women knitting," he writes at the age of twenty-six. "We should paint living people who breathe and feel and suffer and love." And in eight compulsive years he painted stirring images that referred, in then radically modern terms, to the conditions of puberty and fertility, to the states of anxiety, melancholy, and jealousy, to the transforming actions of loving and dying. In the process he re-created and adapted to his needs symbols like the Vampire (fig. 6), the Madonna (fig. 7, colorplate 16), the Maiden and Death (colorplate 10), or the Chamber of Death (fig. 8, colorplate 8) to summarize eventually the newly illuminated sensibilities in his vision of a dance of life. Having painted these equivalents of emotional and organic

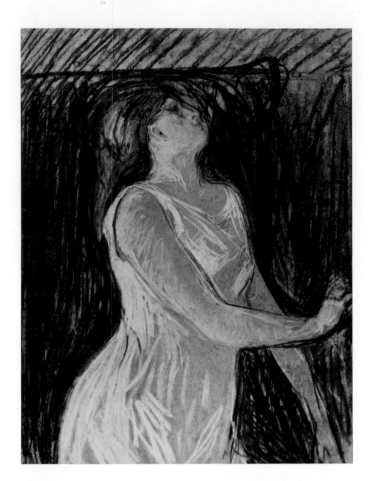

Figure 7. SKETCH OF A MODEL. 1893. Pastel on cardboard, $30^1/_8 \times 20^7/_8''$. *The Solomon R. Guggenheim Museum, New York*

Figure 6. THE VAMPIRE. 1893. Pastel, $22^1/_2 \times 29^1/_2''$. *Munch-museet, Oslo*

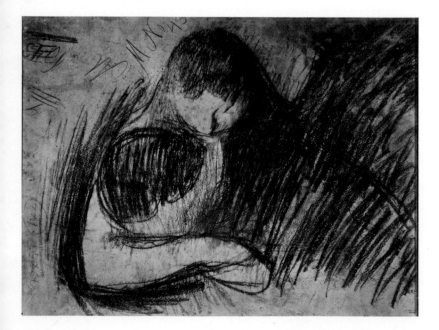

states, Munch would perfect and deepen the evocative power of the visual analogies in numerous etchings, lithographs, and woodcuts to assure through the modest print mediums their widest distribution and their most convenient presentation as a unified theme. The shores of Aasgaardstrand provided the principal stage for paintings and prints, and a limited number of recurring personages became the chief carriers of a highly charged emotional content.

Turning away from a primary concern with optical reality as the Impressionists had conceived of it, the Scandinavian artist reverted to the human condition and drew from it the substance for his inward-oriented art. The dominating themes are evoked through the externalization of a psychic state—a process that aimed for the most immediate and unfiltered transmittal from within and relied simultaneously upon literary and plastic components.

Munch was almost thirty years old when elements of the *Frieze* were assembled in Berlin and shown as a sequence titled *Love*. He had come to Berlin during the previous year upon invitation of the Berlin Artists Association (Verein Berliner Künstler), only to find that the showing of his works caused such violent reactions that the exhibition was closed within a week. Despite his retiring ways, Munch took the incident in stride, partly, perhaps, because he had not been spoiled by favorable reception of his work during previous occasions, but also because he judged correctly that he had involuntarily achieved a succès de scandale which in one stroke catapulted him into the international limelight as "the Munch case" became the favorite gossip of the art world. The stormy reception in Berlin, therefore, was the opening shot for his most fruitful creative period and led, during the subsequent eight years, to the completion of those works for which he is best remembered today.

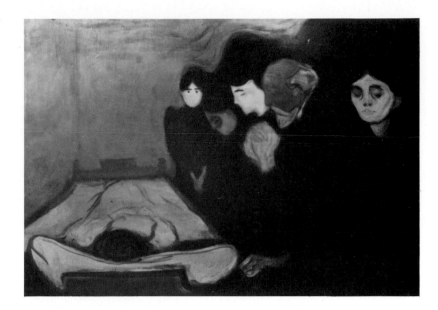

Figure 8. DEATH STRUGGLE. 1895. Oil on canvas, 36¼ × 47½". *Rasmus Meyers Samlinger, Bergen*

The traditional view according to which the "real Munch"—that is to say, the Munch capable of illuminating the most relevant thoughts of his time—is compressed within a decade beginning in 1892 has much in its favor. Seen, however, from the vantage point of Munch's total creation, the *Frieze of Life* becomes merely the most prominent subdivision. As such it is held in balance, in a later stage of his development, by images that found their consummation in the mural decorations of the University Aula in Oslo and by a still later cycle, never executed but intimated, when Munch began to think of his paintings of workers sequentially as a suitable decoration for the walls of Oslo's City Hall. Thus it was the monumental mural decorations that were, throughout the artist's mature life, cause and potential consequence of his cyclic thought pattern.

This is not to say that Munch only worked for mural commissions or that the final states of his large themes were predetermined at the outset. It does mean, however, that as he worked within a loosely relatable range, he recognized with increasing clarity that his paintings and prints, as they left easel and press, were fragments of an emerging comprehensive world view. This unique personal vision was sharpened and deepened throughout his long and diligent life.

As a result, Munch's oeuvre is all of a piece. Notwithstanding a wide range of subject matter and a stylistic evolution of some complexity, the thematic content of his art was predetermined by his basic attitudes, and eventually seeks to subordinate individual works to the cyclic entity that his whole creation gradually became. This continuity of Munch's pictorial thinking is of fundamental importance in the understanding of his art. It expresses itself in various ways: through his lifelong habit of re-creating a once-stated theme in numerous versions, often with the frank intention of replacing a missing picture that had been lost or sold; through equally frequent transformations as the original statement is adjusted and often refined to the requirements of a new medium—the translation of a painting into a print or an etching into a lithograph or woodcut in any sequence. Inevitably, such re-creations reveal the intervening passage of time through the artist's modified handwriting, a new stylistic awareness, or, in extreme cases, a basic change of sensibility.

Transformations of the kind referred to may be observed in *Anxiety* (colorplate 17), a key work in Munch's *Frieze* creation that is unique. The fact that only one version of the oil exists simply means that Munch held on to the work until his death, when his estate passed to

the city of Oslo and eventually to the Munch-museet, and hence did not feel the urge to re-create it. The figurative content of *Anxiety* is based upon the earlier *Evening on Karl Johan Street* (colorplate 9) on the one hand, and on the landscape motif of *The Scream* on the other. As so often, Munch borrowed from himself by using already available themes within a new context. With some deviation from the original, but without diluting his source, Munch first created a lithograph (fig. 88) which, after such simplifications as are inherent in the medium, became the model for a subsequent woodcut (fig. 89). In the course of these transmutations the position of the subject matter in the painting was reversed through the print process until, in the final woodcut, it came full circle. Among Munch's later lithographs, two examples entitled *Anxiety* and *Anxiety Motif* (figs. 9, 10) indicate how firmly he held to underlying

above: Figure 9. ANXIETY. 1915. Lithograph, 8½ × 11¾″. (Sch. 437)

below: Figure 10. ANXIETY MOTIF. c. 1915. 8⅝ × 11⅜″.

14

characteristics as he emerged from the more restricted compass of the *Frieze* into the large patterns of his life work. Despite considerable divergence from the original vision, Munch retains in these later restitutions of the angst motif the same ominous groupings of a driven human collective that had characterized the *Frieze* image of 1894.

As one looks back upon the six creative decades of Munch's life, his work falls into three clearly separable phases: the first begins with his emergence from student ranks in the early 1880s and ends with his last bow to Impressionism in 1892; the second is the decade of the *Frieze of Life* with its two important exhibitions in Berlin, in 1892 and 1902; the third period makes up the remainder of his life and ends with his death in 1944.

Munch's first working decade may be termed preparatory in the sense that it remained within the bounds of established styles—first of Naturalism and then of Impressionism. While much has been made of the originality of his approach to then current idioms, it is only by hindsight that we are able to recognize the features that came to characterize his later work and confer a measure of uniqueness upon the reasoned adaptations of his beginnings. Despite the freshness of his youthful attack, it is likely that had Munch died in 1891, he would have been mourned as Norway's white hope but would have remained unrecorded in the annals of an internationally oriented history of modern art.

The years prior to 1892 were nevertheless very important for the development of Munch's art and for the establishment of his mode of life. He was born on a farm in Løten in 1863; his family soon moved to Christiania, the Oslo of today. Coming as he did from a family of intellectual distinction and growing up under the restricted material circumstances of the Norwegian middle class, the conflict between the rigid bounds of a restrictive environment and the high aspirations of precocious talent already plagued him as a very young man. The pressures of this conflict led him directly into the Christiania-Bohème—the Norwegian equivalent for the Quartier Latin—where, in the heady world of ideas and under a freely drawn moral code, the odious weights of the bourgeois ambiance were lifted. Membership in the world community of a cosmopolitan intelligentsia was the reward for such an independent attitude.

The twenty-one-year-old Munch thus established contact with the local avant-garde to find eventually that through such associations he had paved the way for comparable relationships on a broader, Continental scale that were to remain his natural environment ever afterward. Rather touchingly, he retained a strong link with his simple home through uninterrupted contacts and correspondence with his one surviving sister, Inger, and with his aunt, Karen Bjølstad, who became his foster mother when he was five years old. Young Edvard's commitment to painting dates back to 1881, when he entered the School of Design in Oslo. A year later the nineteen-year-old shared a studio with six fellow artists whose work was supervised by Christian Krohg, Oslo's leading academician. Munch exhibited for the first time at the age of twenty.

During the next decade the young artist gathered the spiritual legacies of his day. He was in touch with art, literature, and prevalent philosophical theories and ideas as these were transmitted through the best informed and most gifted members of the Norwegian intelligentsia. These ideas were subsequently tested and revised through foreign contacts. In 1885 Munch visited Paris for the first time and was exposed to a wide range of impressions gathered in the Louvre as well as in the Salon d'Automne. Despite his frail health and lack of means, a compulsive urge to travel manifested itself early. Gathering stipends wherever he could, and managing eventually to secure a state grant no less than three times in succession, Munch gratified his need for wider exposure and assured his periodic return to Paris. There, apart from a brief and frustrating enrollment in art school, he steeped himself in modernism, which then meant plein air painting, the divisionist mode of Impressionism, and early Post-Impressionist painting. At the same time he attended to his growing domestic reputation through regular exhibitions at home, including his first one-man show at the age of twenty-six.

Thus, in the 1880s and through 1891, in Naturalist and Impressionist essays, the young Munch laid the groundwork for the subsequent outburst that was already slowly maturing as his life began to assume the characteristics that remained essentially valid ever afterward.

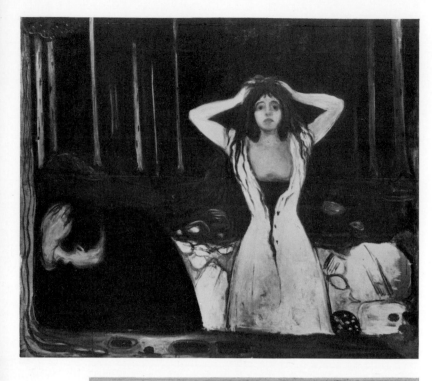

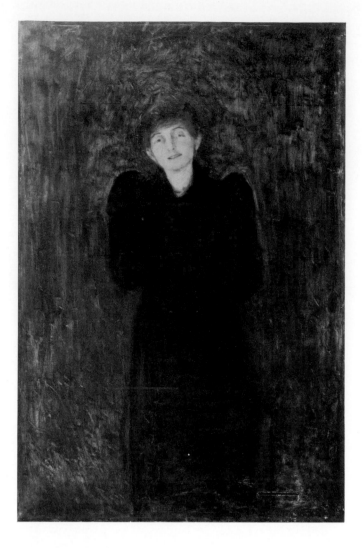

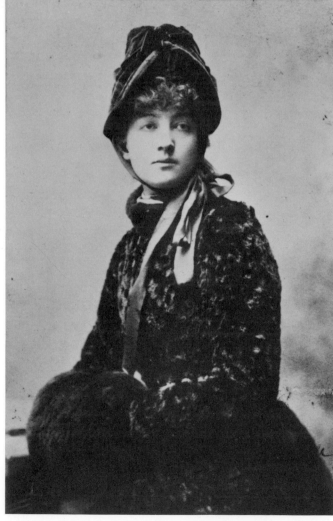

above left: Figure 11. ASHES. 1894. Oil on canvas, 47½ × 55½".
Nasjonalgalleriet, Oslo

above right: Figure 12. PORTRAIT OF DAGNY JUELL PRZYBYSZEWSKI.
1893. Oil on canvas, 58¼ × 39¼". *Munch-museet, Oslo*

left: Figure 13. Photograph of Dagny Juell Przybyszewski

The years of the *Frieze of Life,* when Munch's most tell-
ing contribution was made, may be said to have begun
with his dramatic debut at the Verein Berliner Künstler
in 1892, and to have come to an end ten years later when,
again in Berlin, the *Frieze* cycle was presented in its
fullest and most definitive form. This was the decade of
Munch's emergence as an artist of international stature;
it saw the appearance of the first book devoted to his
work, the publication of serious reviews in Berlin and in
Paris, and publication of a folio of eight of his etchings
by Julius Meier-Graefe. The Norwegian met artists and
literary people of note and associated with them as an
equal and valued contributor to their common intellec-
tual pursuits. The writers who were involved with the

recently founded periodical *Pan* invited his contributions as did, among others, the publisher Vollard in Paris, for whom he began the never completed illustrations to Baudelaire's *Les Fleurs du Mal*. The Polish poet Stanislaw Przybyszewski (fig. 88), August Strindberg (fig. 41), and Meier-Graefe became part of his circle, involving him professionally as well as through their joint infatuation with Dagny Juell, Przybyszewski's seductive Norwegian wife (figs. 12, 13), who was the model for Strindberg's *Aspasia*. His base during the first part of the decade was Berlin. Later it shifted to Paris, where Stéphane Mallarmé (fig. 14) and other Symbolists looked upon the Norwegian's appearance with favor, and where Munch exhibited in two successive years at the Salon des Indépendants and at Samuel Bing's gallery L'Art Nouveau. But neither Berlin nor

Paris were in any sense permanent homes, since he had established and maintained a travel routine that annually included exhibitions in a host of German and Scandinavian cities as well as regular retreats to the Norwegian seaside. Aasgaardstrand, scene of the *Frieze* images, had attracted Munch for some time (figs. 15, 16), and after years of summer renting he acquired a house there in 1897. Eventually his traveling radius was

Figure 14. STÉPHANE MALLARMÉ. 1896.
Lithograph, 20½ × 11¾″. (Sch. 79/b)

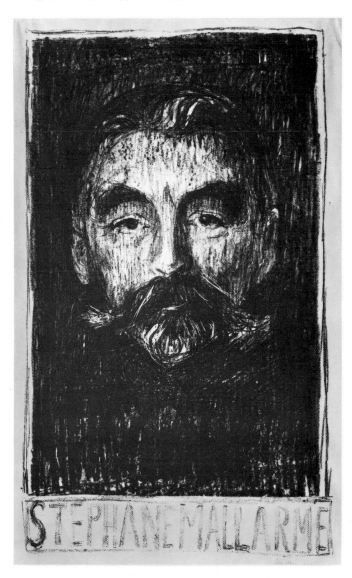

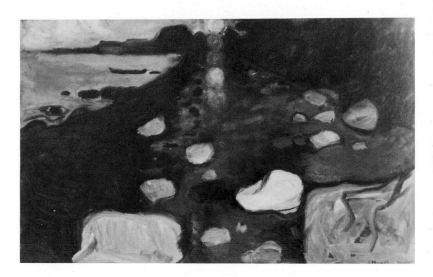

Figure 15. MOONLIGHT ON THE SHORE. 1893.
Oil on canvas, 24½ × 37½″. *Rasmus Meyers Samlinger, Bergen*

Figure 16. Munch painting at Aasgaardstrand in 1889; his sister Laura stands in the doorway

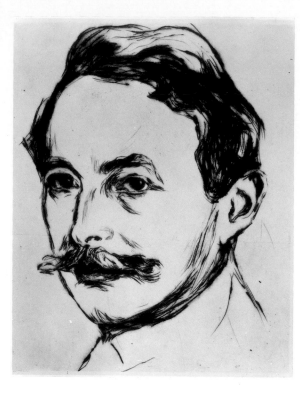

left: Figure 17. PORTRAIT OF DR. MAX LINDE,
FROM THE "LINDE PORTFOLIO." 1902. Drypoint, 10⅞ × 8⅝". (Sch.179)

above: Figure 18. THE HOUSE OF DR. LINDE (GARDEN SIDE),
FROM THE "LINDE PORTFOLIO." 1902. Lithograph, 6½ × 15¼". (Sch.176)

increased to include Austria and Italy, where in 1899 he participated for the first time at the Biennale.

By 1902, however, there were signs that the routines had run dry and changes were due. His quarrels with other artists and with friends became more frequent and destructive, and he even lost the joint of a finger through the gun-playing antics of an aggressive lady who was determined to keep his waning attention. On the positive side, new friendships developed, most important that with a wealthy oculist from Lübeck, Dr.

Max Linde (fig. 17). Linde first bought Munch's *Fertility* (colorplate 25), then wrote a book about his recently discovered painter-friend, and eventually commissioned the so-called *Linde Portfolio*, which consists of a suite of prints with Linde, his home, and his family as subject matter (figs. 18, 105, 106). Of great importance also was his meeting with Gustav Schiefler, who collected his prints and afterward became Munch's print cataloguer.

During this second and supremely important creative

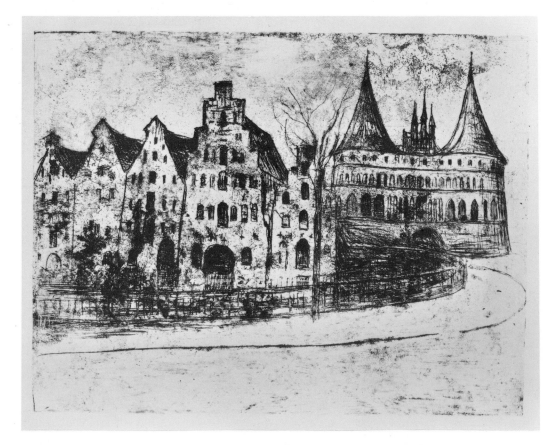

Figure 19. LÜBECK.
1903. Etching and
aquatint, 18½ × 24⅜".
(Sch.195)

phase of his life Munch conceived and completed in quick sequence the three dozen paintings and the accompanying prints that marked him as a genius in the minds of his contemporaries and that, to this day, remain the basis for our interest in his art.

What may be broadly characterized as a third phase covers a less homogeneous and, biographically as well as stylistically, a more complex sequence of decades. A restless six-year period during which Munch's travel mania assumed hysterical proportions was punctuated by a nervous breakdown in 1908. Stylistic modifications that had announced themselves before took full effect in the subsequent period of convalescence. In view of the constancy of Munch's forms after 1892 and an artistic disposition resisting rather than seeking change in his own work, the reorientation of his art in about 1907 points to inner, psychic, rather than to formal, aesthetic causes. Regardless of the impetus, these changes led to a break in the extraordinary unity of Expressionist and Symbolist components which until then had marked Munch's work with such uniqueness. Instead we witness a turn toward an externally oriented, struc-

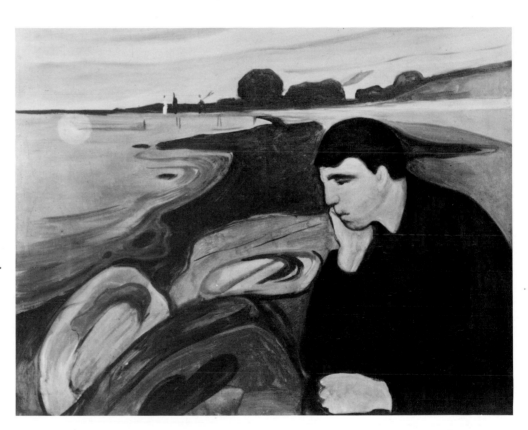

Figure 20. MELANCHOLY. 1894–95.
Oil on wood, 18 × 29″.
Rasmus Meyers Samlinger, Bergen

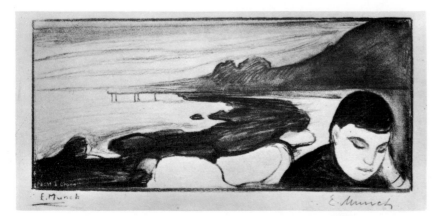

Figure 21. MELANCHOLY. c.1891–92.
Lithograph, 2½ × 5″

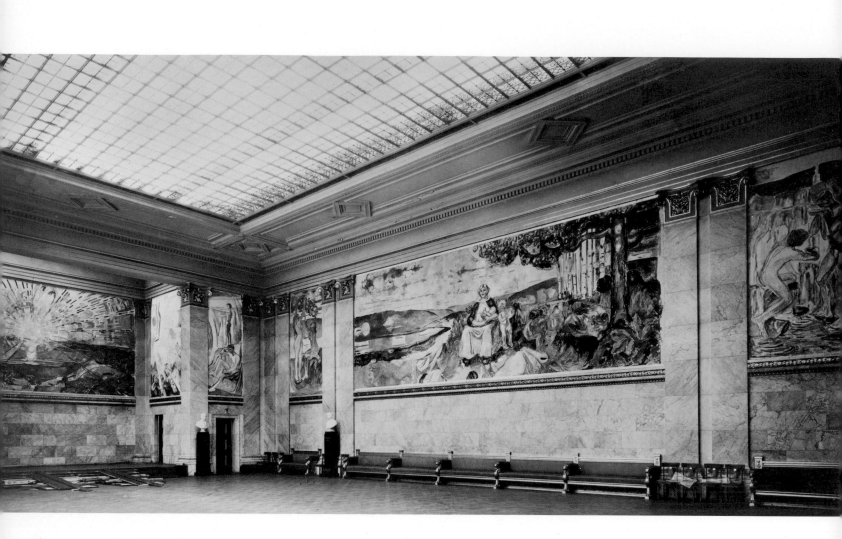

Figure 22. Interior of the Aula (Assembly Hall) of the University of Oslo

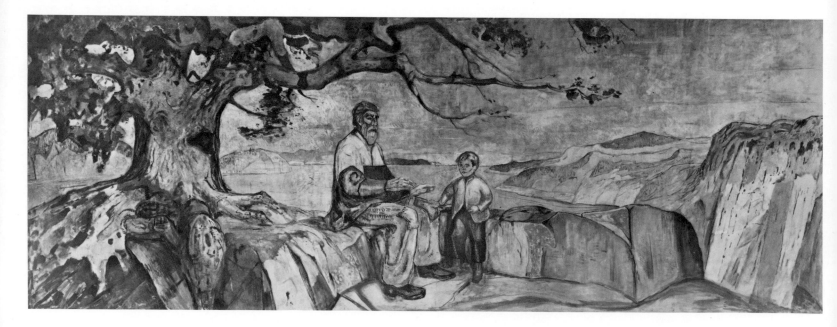

Figure 23. HISTORY. 1909–11. Oil on canvas, 14′ 11⅛″ × 34′.
Aula (Assembly Hall), University of Oslo

turally strengthened, and emotionally diminished art in which a degree of detachment and resignation takes the place of the formerly consistent mood of terror and anxiety caused by a painful and seemingly unavoidable confrontation with the inner self. The unifying symbol of the new extroverted phase is *The Sun* (colorplate 33) of the University murals, which dominates the work of this period with startling force and unequaled radiance.

Characteristically, in Munch's case such a reorientation, while observable at first in individual works, craves a cyclic embodiment, preferably through monumental mural sequences such as he had always desired but unhappily never consummated for the *Frieze of Life*. An opportunity now presented itself, for Munch was invited to compete with five other artists for a commission to decorate the Assembly Hall or Aula of Oslo's University. After much delay and needless annoyance to the artist, Munch's friends on the jury forced a favorable decision, thereby not only returning a just and well-deserved judgment, but also securing a dignified and permanent place for one of the greatest mural sequences in modern art.

The Aula murals consist of eleven monumental canvases stretched on the walls of a large rectangular hall that was built in a neoclassic style while the works themselves were in progress, between 1909 and 1911 (fig. 22). They can be seen as a continuation of the late *Frieze* creation, and are just as much a comprehensive testimony of the artist's externalized vision as the *Frieze of Life* was of the deep-seated realities within him. Aware of the essential connection, Munch compared the two creations, stating: "The *Frieze of Life* presents the individual's sorrows and joys observed close at hand—the University pictures embody the powerful eternal forces."

Ten exactly symmetrical creations of varying size and shape are unified by the eleventh, central Sun image. The themes symbolize life and love, age and youth, but not death, sickness, or pain. Among them two gigantic canvases representing the male and the female principles, conceived of by Munch in emphatically dualistic terms, face each other across the aisle of the Assembly Hall (figs. 23, 24). On the left, a mighty tree with wild, far-reaching branches offers cover to a story-telling patriarch who imparts his wisdom to an intently listening boy. In a gentler vegetation, sheltered by a high, straight tree with ordered and ample foliage, an infant is breast-fed by an imposing mother figure while other children play naked in the sun. Water and land,

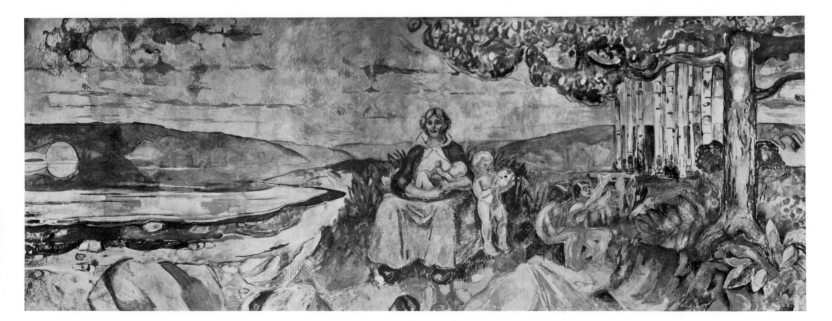

Figure 24. ALMA MATER. 1909–11. Oil on canvas, 14′ 11⅛″ × 34′.
Aula, University of Oslo

21

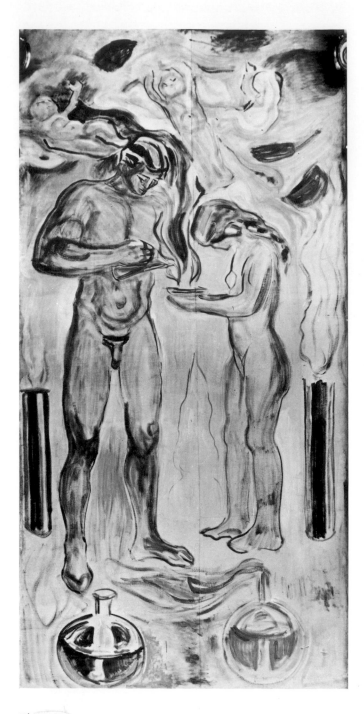

Figure 25. THE CHEMISTRY. 1909–11. Oil on canvas,
14′ 11⅛″ × 7′ 4⅝″. *Aula, University of Oslo*

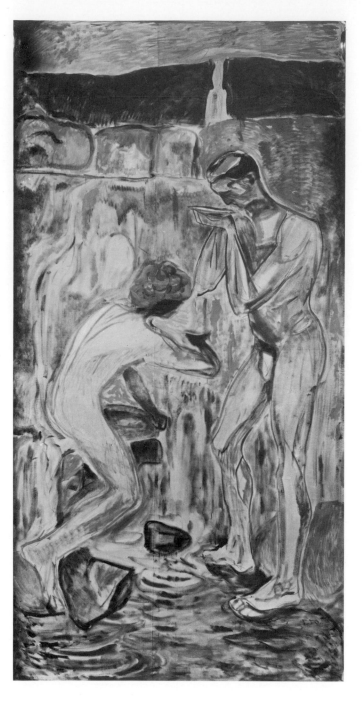

Figure 26. THE FOUNTAIN. 1909–11. Oil on canvas,
14′ 11⅛″ × 7′ 4⅝″. *Aula,University of Oslo*

rocks, earth, and vegetation are bathed in light that breaks forth from a clouded sky.

The principal confrontation between masculinity and femininity continues as the leitmotif for the four smaller complementary themes. Man and Woman are seen in innocent nudity. Man pours a love-and-life potion into fiery containers held by Woman as upward-reaching, embryonic life surrounds them both (fig. 25). And on the opposite wall, Woman offers Man purifying and strengthening libations (fig. 26). Other themes include the joy of innocent maidens who reach for a fruit with-

out sin (fig. 27), opposed by erotic love under a sun mirrored in pure waters (fig. 28), and mutual yearning between womanhood and manhood, as analogous pairs confront each other across the waters. The Aula murals are a hymn to joy and a celebration of creation conveyed through symbolic, but not fully explicit, themes. They were executed in colors ranging from pale to bright, but without reliance upon the sinister color content characteristic of the darker themes of the *Frieze*. The ultimate symbol of such joyousness is the sun itself, and Munch reserved the large facing wall for this central and

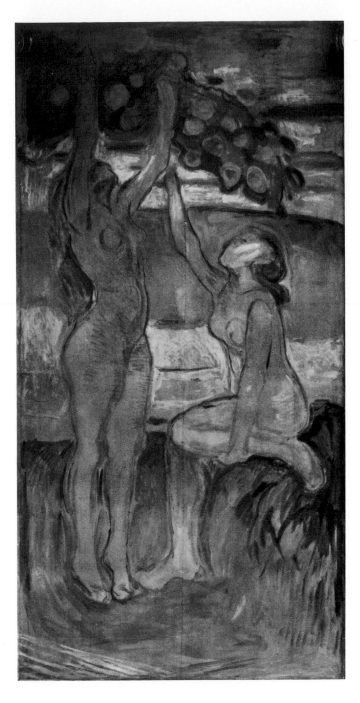

Figure 27. WOMEN HARVESTING. 1909–11. Oil on canvas,
14′ 11⅛″ × 7′ 4⅝″. *Aula, University of Oslo*

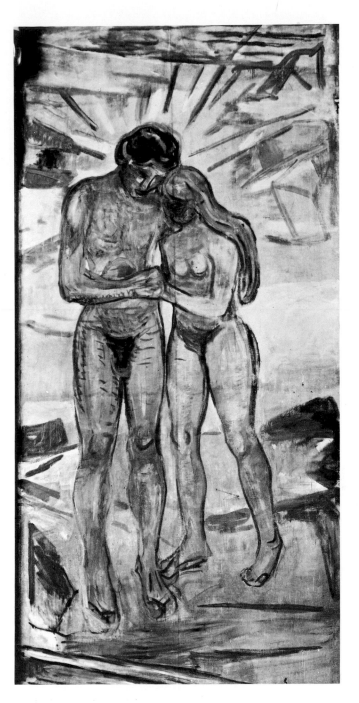

Figure 28. NEW RAYS. 1909–11. Oil on canvas,
14′ 11⅛″ × 7′ 4⅝″. *Aula, University of Oslo*

self-sufficient image, allowing it to dominate the mural series with unprecedented force, clarity, and radiant beauty.

It may be argued that the compression of Munch's life work into only three major subdivisions amounts to an oversimplification, and that the undivided viewing of his art from 1902 to the end of his life in 1944 does violence to the subtler movements that occur during this prolonged period. If such an objection is sustained, the

placement of other milestones would fall within the years between 1912 and 1916. For it was then that the University murals saw completion and came to be permanently installed in the space that Munch had imagined for them. It was then also that the artist, having turned fifty, withdrew to a contemplative existence, acquiring a house at Ekely near Oslo. From this time on he was to make only occasional and increasingly rare sorties into the larger world of turbulent haste.

Such changes may well have coincided with the instinctive realization that the mainspring of an art ever

dependent upon a state of psychic tension had been used up. Contemporary Munch biographers, aware of the transformations that were taking place, reacted with understandable protectiveness toward the revered master, and often postulated a new and important resurgence of his art. In view of some outstanding works created during the balance of Munch's life it is neither necessary nor perhaps just to view the nearly three decades at Ekely in terms of a decline; the more so since Munch's mastery as a painter was if anything enhanced during his old age. It must be stated, however, that after the explosive decade from 1892 to 1902, with its consolidating aftermath, Munch had no longer the power to create images that convincingly spoke for his time. He did have the power to gather his own crop and to give us works of stunning beauty, which when seen within the context of his own development and within the wholeness of his unified creation continue to move us.

It would be a serious omission not to refer to some works of the artist's very old age in which he succeeds, like the old Rembrandt or perhaps the Shakespeare of *The Tempest*, in reawakening the ancient shadows and in making them dance on a stage that is now serene and illuminated by the cool and dispersed light of sovereign detachment. With the power to reach deep within himself, he brings forth in moments of inner illumination the imagery that once forced itself toward the surface through painful outcries, but which now is contained within an emotional scale mellowed and deepened through the liberating processes of a lifelong artistry. It is through paintings such as the later version of *Starry Night* (colorplate 38) or some of his aged self-portraits that a final synthesis is admirably achieved.

The elusive personality of Edvard Munch cannot easily be summarized; he shies away from searchlights, leaving those who would train them upon him in the dark, confused by the shadows cast by their own light source. The aura of mystery that emanated from his romantic image and led to his typification as the "Genius from the North" does little to make him more comprehensible. To those who knew him in his youth, and recorded

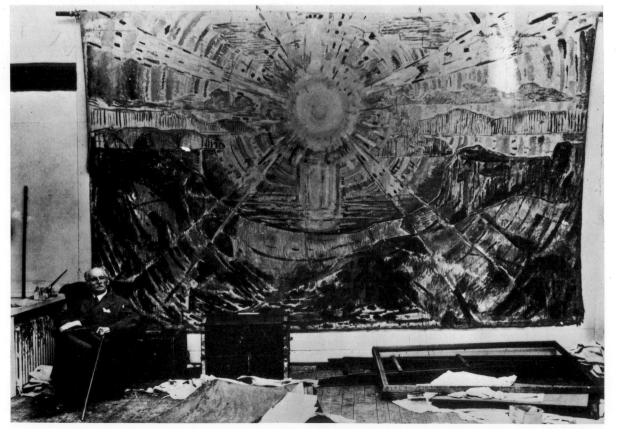

Figure 29.
Late photograph of Munch (c. 1938?) in his studio with a recapitulation of THE SUN

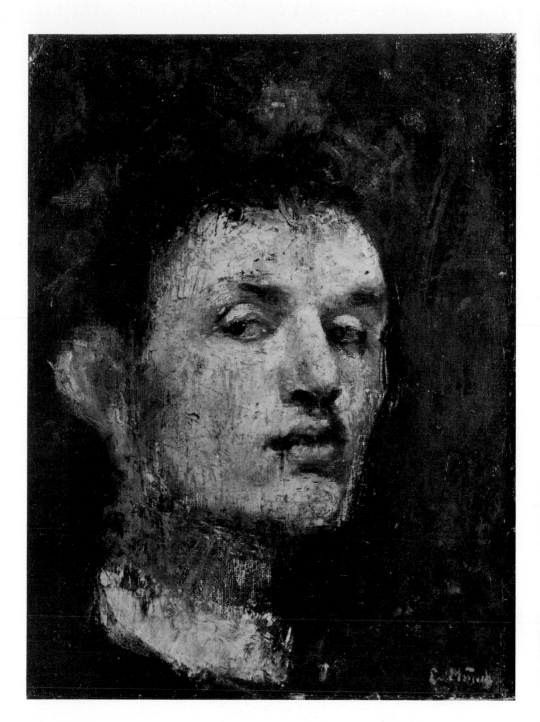

their impressions, he was neither distant nor withdrawn, but rather a Parsifalian embodiment of the guileless fool who would pursue his off-beat ideas with single-mindedness and indifference to conventional precedent. What he did as a painter, according to such witnesses, was the result of the same uninhibited directness that in daily life made him cut off the tails of his evening coat when they got in the way, turn around his stiff formal collar when one side was soiled, or paint in glorious hues over a hotel bedsheet after inadvertently spilling ink on it. Shy and formal with women and influenced by misogynist ideas derived from the popularization of Schopenhauer, he was nevertheless most susceptible to feminine lure.

Given to excessive quarrelsomeness, intemperate drinking, and the use of stimulants, he undermined a constitution that was far from sturdy in the first place, burdening his nervous system until it broke under the strain. As he grew older, a suspiciousness reaching at times the intensity of a persecution mania removed him from some real but mostly imagined enemies, and from many a friend as well. Such symptoms were accompanied by an increased yearning for seclusion. During the convalescence following his nervous breakdown in 1908 he avoided all but the simplest human company; instead he communed with nature in the austere landscape of Kragerø. While thereafter the need for a calmer life was

registered by diminished travel and longer stretches of uninterrupted work at Ekely, withdrawal was never complete. Even in old age Munch would break away from his hideout to visit exhibition openings, to see the work of younger painters, and to get a whiff of the changing looks of the advancing century.

Munch's manifest shyness and his lone-wolf attitudes are not contradicted by the mania for travel that pursued him in varying degrees throughout his life. As one follows the data of his movements from year to year and from month to month, it becomes difficult to imagine how in an age of ship and railway travel Munch could live up to this self-imposed itinerary. Frail as he was, his travels were combined with a steady and prolific outpouring of work. A typical sequence in 1898, for instance, shows him participating in exhibitions in Nor-

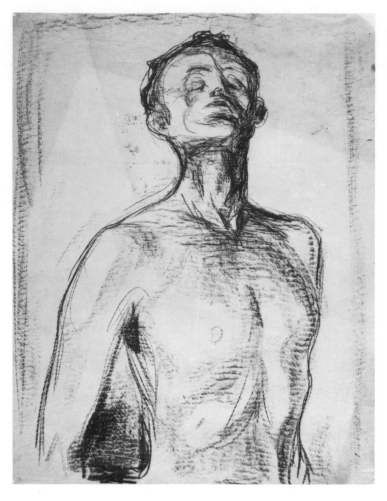

Figure 31. IN HELL, SELF-PORTRAIT. C. 1895.
Oil on canvas, $32\frac{5}{8} \times 23\frac{5}{8}''$. *Munch-museet, Oslo*

Figure 32. SELF-PORTRAIT. C.1915.
Charcoal, $32\frac{5}{8} \times 23\frac{5}{8}''$. *Munch-museet, Oslo*

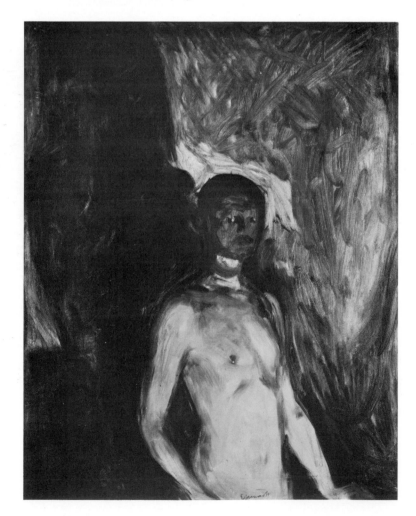

way and Denmark before arriving in Berlin during the month of March. By May he is in Paris taking part in the annual Salon des Indépendants, returning to Oslo by June. As was his habit, he then spent part of the summer at the seashore at his beloved Aasgaardstrand, going back to Oslo in the fall. Throughout his most active years, until his settlement at Ekely at the age of fifty-three, Munch followed such routines without letup, and at times forced them into such high gear that only psychopathological explanations would seem to provide satisfactory answers. A deep and permanent unrest, bordering on hysteria, must have forced the artist from periods of total withdrawal into equally exaggerated mobility.

As a result, one cannot but wonder whether such frequent moves are not in reality yet another protective device against detection—a shy animal instinct that

left: Figure 33. Photograph of Munch, c.1895

below: Figure 34. Photograph of Munch during his middle years, c.1900

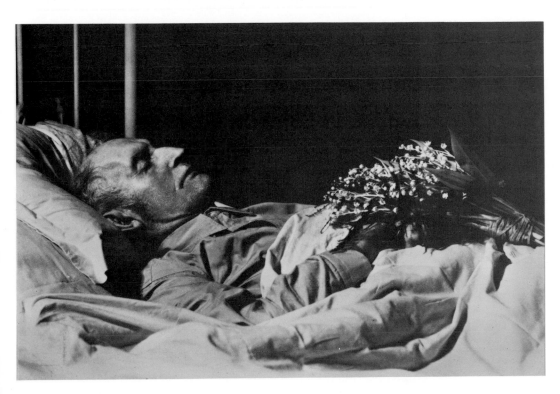

above: Figure 35. Photograph of Munch taken late in life, c.1938

left: Figure 36. Deathbed photograph of Munch, January 23, 1944

27

causes rushed escapes from one hideout to another as the hunters approach. Such notions are strengthened by the fact that the traces left by Munch's wanderings are slight, as if his footsteps were quickly covered.

The artist's copious writings increasingly accessible in the decades following his death, his diary entries and his regular if often inconsequential correspondence with his family, together with his statements about the meaning of the *Frieze* and the Aula paintings, constitute important firsthand sources. What Munch is reported to have said on various occasions must be taken with a grain of salt even when the transmitting agent is trustworthy, partly because memories are rarely dependable in such matters, and also because the context of a conversation and the inflection of a particular statement can seldom be reliably reconstructed. What remains are Munch's recorded actions, which are often in curious contrast with his Parsifalian image. Munch was certainly not ineffective in worldly matters. He was competent, as has already been mentioned, to obtain the various scholarships that satisfied his youthful need to travel (an ability that even led to opposition in the press, which in turn evoked the artist's defense); he managed his dealers in his quiet way, sold respectably at auctions, controlled reproduction rights, determined his participation in publication ventures, assured the eventual placement of his murals, managed collectors and patrons, raised and borrowed money when necessary, and eventually spent his own money to assist others. All these surely are not the actions of an inept or confused individual. And while human relations occasionally did erupt into violence in such dramatic instances as the shooting incident with a jilted lady in which he lost the joint of a finger, the coming to blows with alienated poet friends, or the comical police arrest that followed a meaningless public disorder, Munch nevertheless calculated involvement and detachment with shrewd judgment and saw clearly the practical advantages of Franciscan virtues. His messy ways, undeniable in some respects, appear to have been balanced by an insistent discipline that reduced irrelevant encumbrance to a minimum, allowing him to concentrate on his creative aims. Thus contradictory character traits nevertheless persist and Munch's personality, more than a quarter-century after his death, remains shadowy, resisting the high-powered exploratory techniques of our age and imposing a certain reticence upon those who seem to know more than they are willing to say.

To know Munch at all therefore means to know him through his work, from which some obvious deductions lead back to the man. By weighing the impact of such paintings as the *Chamber of Death* (colorplate 8) it is possible to deduce the injury to his psyche caused by the series of family deaths—that of his mother when he was five years old, his sister Sophie when he was fourteen, and his father when he was twenty-six. His work reveals idiosyncrasies and fixations that were not uncommon in themselves but so highly developed with Munch as to assume pathological dimensions. Who, for instance, would imbue nature with such sinister attributes as Munch did in *The Scream* (colorplate 13), where the piercing outcry not only seems to undermine the visible order but threatens man's protective safeguards against chaos and insanity? Or why would Munch so often exhibit an obviously acute space phobia, lodging it within such works as *Anxiety* (colorplate 17), where a massed throng rolls forward in sinister contrast with the emptiness of the street; in the elongated railings of *Girls on the Jetty* (colorplate 23) and *The Scream*; or in the tomblike attenuation of the inn which encloses Munch's self-portrait of 1906 (colorplate 29)? Is it possible to contemplate the *Galloping Horse* (colorplate 35) of 1912 without feeling that Munch's mind, having shed some of its worst nightmares, has now somehow been startled back into a panic reminiscence by that self-engendered image of a mute and frightened animal in all but uncontrolled flight down a hollow road devoid of exits or turns? And conversely, does not an eventual calming and a resigned acceptance of the inevitable order of things mirror itself in the sturdy shapes and pure colors of the Kragerø landscape (colorplate 34), or in the serenity of the late *Starry Night* (colorplate 38), so different in mood from the majestic but charged image that bore this same title in the strained and nervous 1890s (colorplate 15)? In view of such characteristic examples, it is clear that Munch, for whom art, by his own testimony, had strong therapeutic power, ministered to his injured and eventually healing psyche by directly confronting his problems in his work. Thus his work reveals the secret self that he hid with such elaborate cunning in his life. It would almost seem that, para-

doxically, the egocentrically structured Munch was forced to tell through forms and images what he would not divulge through speech.

Munch was simultaneously a shaper and the product of his time—a time that saw stylistic transitions from Naturalism and Impressionism to Symbolism and Expressionism. Such transformations and their creative manifestations were not limited to the visual arts. Literature, music, indeed the style of the period as a whole, were affected by the currents of a changing sensibility. Symbolism in particular was in the air as Munch's art matured. Jean Moréas had published his *Manifeste du Symbolisme*, which heralded a new literary movement, in 1886. Articles on the subject were also published at the same time by Félix Fénéon, while Strindberg, two years later, speculated on the meaning of Naturalism, its uses and abuses. In the 1890s Symbolism was seen as contradiction of and reaction against the narrowing scope of Naturalism, and Munch therefore was consonant with his

time as he evoked wider reaches of the human spirit through a symbolic rendering of nature and man.

Munch, from his early bohemian period, knew many members of the avant-garde, establishing close friendships with some of them. His long-lasting amity and extensive correspondence with the composer Frederick Delius (fig. 37) has been fully documented by John Boulton Smith. Earlier and more significant contacts existed with poets and writers. Stanislaw Przybyszewski, Sigbjørn Obstfelder, Emanuel Goldstein, Hans Jaeger, Ibsen, Strindberg, Mallarmé, Gunnar Heiberg, and many others were close to Munch and to his work (figs. 88, 38, 39, 41, 14). Although it may be difficult to know to what extent Munch read the original texts, his awareness of ideas traceable to the philosophies of Swedenborg, Kierkegaard, Schopenhauer, and Nietzsche (fig. 40) establishes clear links between his creative attitudes and the intellectual climate of his time. On March 5, 1929, in a letter to Intendant Ragnar Hoppe of the Nationalmuseum in Stockholm, Munch himself re-

above: Figure 37. THE COMPOSER DELIUS AT WIESBADEN. C.1922.
Lithograph, 10 × 15¾". (Sch.498)

right: Figure 38. HANS JAEGER. 1896.
Lithograph, 18⅛ × 13". (Sch.76)

29

above: Figure 39.
IBSEN IN THE GRAND CAFÉ.
1902. Lithograph, $16\frac{7}{8} \times 23\frac{1}{4}''$.
(Sch.171)

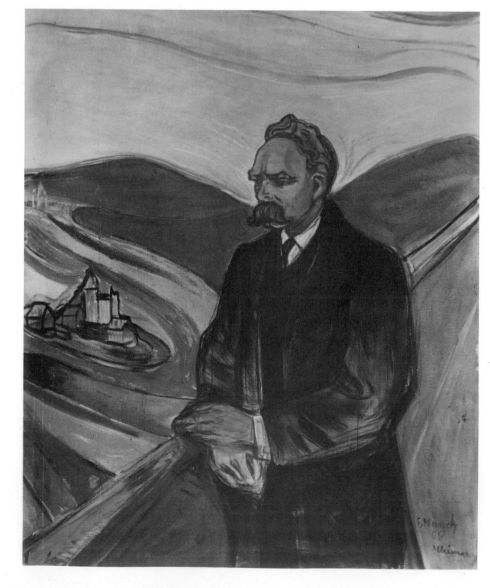

Figure 40. IDEAL PORTRAIT OF
FRIEDRICH NIETZSCHE. 1906.
Oil on canvas, $79\frac{1}{8} \times 63''$.
Thielska Galleriet, Stockholm

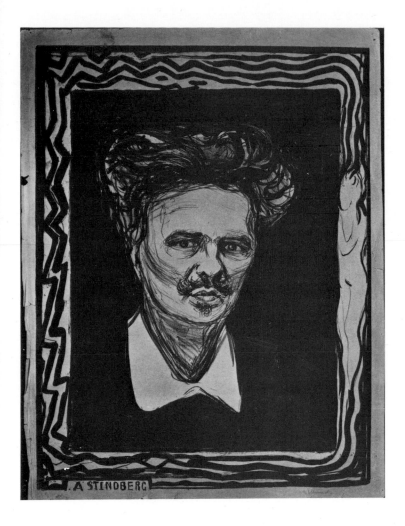

Figure 41.　AUGUST STRINDBERG. 1896.
Lithograph, 24 × 18⅛″. (Sch:77/II)

Such striking parallels between painter and writer may account for Strindberg's extraordinary grasp of Munch's art. His short essay, which Munch described as "poems in prose," may well be the most succinct summarization of Munch's major contribution. It appeared on the occasion of the artist's exhibition at the gallery L'Art Nouveau in Paris and is quoted here as it appeared in *La Revue Blanche* on June 1, 1896.

THE EDVARD MUNCH EXHIBITION

Quelques incompréhensibles que soient
vos paroles, elles ont des charmes
BALZAC–*Séraphita*

Edvard Munch, aged thirty-two, the esoteric painter of love, jealousy, death, and sadness, has often been the victim of the deliberate misrepresentations of the executioner-critic who does his work with detachment and, like the public executioner, receives so much per head.

He has come to Paris to be understood by the initiate, with no fear of dying of the mockery which destroys cowards and weaklings but which, like a shaft of sunlight, lends a new brilliance to the shield of the valiant.

It has been said that music should be composed on Munch's paintings for their true interpretation. That may be so, but in the absence of a composer I shall provide the commentary on this group of pictures so reminiscent of Swedenborg's visions in the rapturous wisdom of conjugal love and the voluptuous folly of sensual love.

The Kiss. The fusion of two beings, the smaller of which, shaped like a carp, seems on the point of devouring the larger as is the habit of vermin, microbes, vampires, and women.

Alternatively: Man gives, creating the illusion that woman gives in return. Man begging the favour of giving his soul, his blood, his liberty, his repose, his eternal salvation, in exchange for what? In exchange for the happiness of giving his soul, his blood, his liberty, his repose, his eternal salvation.

Red Hair. A shower of gold falling on a despairing figure kneeling before his worse self and imploring the favour of being stabbed to death with her hairpin. Golden ropes binding him to earth and to suffering. Rain of blood falling in torrents over the madman in quest of unhappiness, the divine unhappiness of being loved, or rather of loving.

Jealousy. Jealousy, the sacred awareness that one's soul is one's own, that it abhors being mingled with another man by woman's agency. Jealousy, a legitimate

marked: "I have only this last year made acquaintance with Kierkegaard and there are certain peculiar parallels.—I now understand why my works so often have been compared with his.—This I had not understood before.—"

In this connection Munch's sometimes tempestuous friendship with Strindberg is particularly revealing. Strindberg and Munch accepted from Schopenhauer the conflict between the sexes and the love-hate relationship between man and woman. The ambivalent view of woman as desirable and loathsome was also shared and expressed by both, although the much-married Strindberg was clearly more misogynistic than the bachelor Munch. Both, however, succeeded in transferring an almost unbearable burden from the actuality of their lives to the sublimating forms of art.

egoism, born of the instinct to preserve the self and the race.

The jealous man says to his rival: "Away with you, worthless fellow; you will warm yourself at fires I have kindled; you will inhale my breath from her lips; you will suck my blood and remain my slave, for you will be ruled by my spirit through this woman, who has become your master."

Conception. Immaculate or not, it comes to the same thing: the red or gold halo crowns the accomplishment of the act, the sole end and justification of this creature devoid of existence in her own right.

The Scream. A scream of terror in the presence of nature flushed with anger and about to speak through storm and thunder to the petty hare-brained creatures posing as gods but without a godlike appearance.

Twilight. The sunlight fades, night falls, and twilight changes mortals into ghosts and corpses as they return home to envelop themselves in the shroud of their beds and to drift off into sleep. A seeming death which re-creates life, a faculty of suffering, originating in either heaven or hell.

Three Stages of Woman.

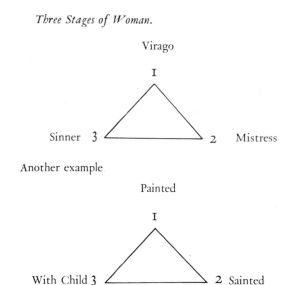

The Shore. The waves have snapped the tree-trunks but underground the roots are still alive, creeping along the dry sand to drink at the everlasting spring of their mother the sea! And the moon rises like the dot on an "i," completing the melancholy and infinite desolation.

Venus rising from the waves and Adonis coming down from the mountains and villages. They make a pretence of watching the sea for fear of drowning in a look which will annihilate the self and merge them both in an embrace in which Venus becomes partly Adonis, and Adonis partly Venus.

AUGUST STRINDBERG

Figure 42. OMEGA AND FLOWERS, FROM THE PORTFOLIO "ALPHA AND OMEGA." 1908–9. Lithograph, $10\frac{1}{4} \times 7\frac{3}{8}$". (Sch.318)

During his convalescence at Dr. Jacobson's clinic in 1908–9, Munch himself wrote a charming prose-poem, a symbolic fable in French, and illustrated it with eighteen lithographs and vignettes. *Alpha and Omega* is consistent with the pessimistic assessment of the male-female relationship of both Munch and Strindberg. The young couple are the first humans to inhabit a lush tropical island, and Omega, true to the notion that woman is an inconstant creature, cannot be faithful to Alpha. Her first "extra-marital" encounter is with the serpent, and one day Alpha meets and slays him as Omega looks on from a distance. She proceeds to cuckold Alpha with a bear, a poet-hyena, a tiger—with all the beasts on the island. "The eyes of Omega were changeable; normally they were light blue. But when she looked at her lovers, her eyes turned black with traces of carmine-red, and at such moments she used to hide her mouth behind a flower. The heart of Omega was fickle." Loving is her favorite pastime, but

below: Figure 43. OMEGA'S EYES, FROM THE PORTFOLIO
"ALPHA AND OMEGA." 1908–9. Lithograph, 9 × 7⅜". (Sch.319)

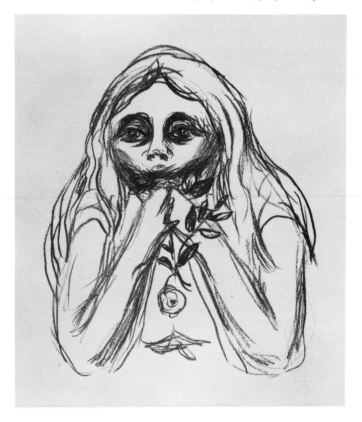

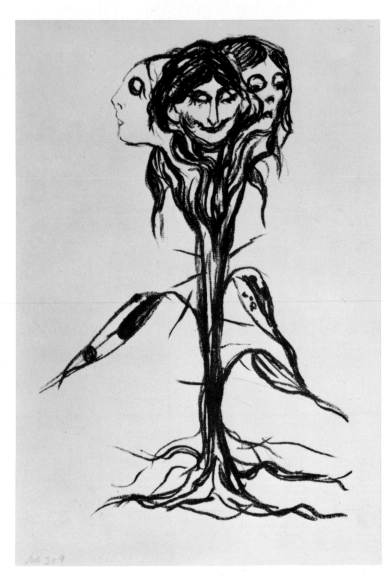

right: Figure 44. VIGNETTE, FROM THE PORTFOLIO "ALPHA
AND OMEGA." 1908–9. Lithograph, 11¾ × 7⅜". (Sch.309)

she becomes bored and flees on a roebuck's back. Alpha remains and lives alone and in despair, surrounded by all of Omega's children, "little pigs, little snakes, little monkeys, little wild animals, and other bastards of man," who call him father. One day Omega returns and Alpha, filled with rage, strikes her a death blow. "When he leaned over the body and saw her face he was terrified by its expression. It was the very same that she had had in the forest when he loved her most. While he was looking at her, he was attacked from behind by all his children and the animals of the island, who tore him to pieces. The new generation filled the island " (figs. 42, 43, 44).

While Munch seemed to prefer the company of literary men to that of painters, there is nevertheless strong evidence of his dependence upon pictorial sources derived from the works of others. In 1894 Przybyszewski, in the first publication ever devoted to Munch, mentioned the Norwegian's indebtedness to

the then popular Belgian artist Félicien Rops. Writings by Otto Benesch, Frederick B. Deknatel, Edith Hoffmann, Ingrid Langaard, Werner Timm, and others discuss Munch's awareness of and in some instances admiration for Arnold Böcklin, Max Klinger, Dante Gabriel Rossetti, Jan Toorop, and Félix Vallotton. In all these instances the source tends to be absorbed and incorporated rather than followed, and the result therefore remains free from obvious derivation. With Munch, as with many great artists, originality remains a baffling concept. Inheritor of traditions and attuned to his own time, Munch invented, in a sense, little enough. The cyclic, sequential imagery of the fin-de-siècle, the symbolic intent and the language of Symbolism, as well as many a recurrent image were common property of the period. Munch's uniqueness therefore rests largely on his capacity to imbue an available vocabulary with an intense veracity and a pulsating sense of reality.

The relation of an artist's work to the sequence of art history—of paintings to other paintings—is arrived at ex post facto and frequently differs from the artist's creative intentions. The judgments of an artist's contemporaries and those of succeeding generations are, however, pertinent for the art historical framework, and serve as an aid to future evaluations in the changing opinions of men. No artist derives from a single model nor is he an exclusive influence upon those who follow him. With Munch too, the strength of his influence upon his progeny, the degree of his dependence on his precursors and his contemporaries is complex and not reducible to a simple sequential order. That he explored and demonstrated new formal possibilities

and that he created new and potent images is evident beyond a doubt.

That the strength of Munch's vision was apparent to his contemporaries is evidenced in the famous Sonderbund exhibition held in 1912 in Cologne. Munch was given a separate exhibition room—an honor he shared only with the three Post-Impressionist patron saints: Cézanne, Van Gogh, and Gauguin. Also exhibited were younger painters upon whom the wrath of the philistines descended much as it had upon Munch two decades earlier. Cubists and Futurists, Fauves and Expressionists, as well as many artists whose stylistic classification had to await a retrospective ordering process, were included in this major assemblage of contemporary art. The placement of Munch's work at the fountainhead of the modern movement was, of course, indicative of the high regard that the almost fifty-year-old Norwegian commanded within an emerging generation. It meant a triumph for those who had accompanied him with confidence and admiration through the prolonged periods of rejection and abuse to which he had been subjected from the time he dared to show his youthful work in Oslo's annual State exhibitions in the 1880s.

Despite such a favorable assessment of Munch's art in relation to Cézanne's, Van Gogh's, and Gauguin's, the four supports for such a Post-Impressionist platform seem uneven from the perspective of more than half a century. Munch was younger than any of his Post-Impressionist peers and shared with them a transitory preoccupation with the Impressionist mode. Like them he exercised a critique upon Impressionism before supplanting the inherited style with an alternative of his own making. But owing to the particular interaction between Munch's creative contribution and general stylistic developments, Munch's departure, unlike those of Van Gogh or Gauguin, seems strangely muted, as if those who had so recently preceded him had preempted the most rewarding possibilities and left to him an amalgam of recently articulated components. It is hardly accidental in this context that Munch's art, despite its incontestable uniqueness, is best named through the composite term *Expressionist-Symbolism*—a double designation that harks back to Van Gogh and Gauguin respectively.

As the Sonderbund exhibition confirms, there is no doubt that Munch was important for the Brücke

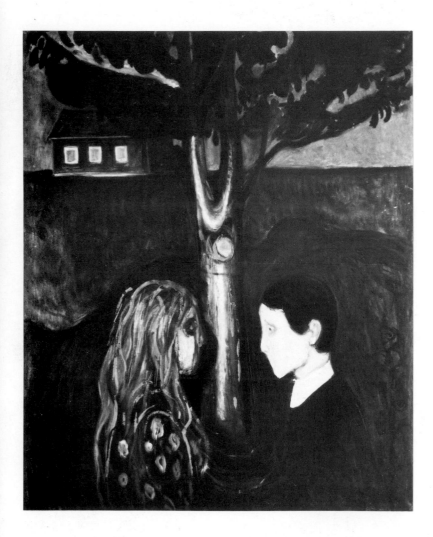

Figure 45. EYE TO EYE. c.1893. Oil on canvas, 53¼ × 43¼".
Munch-museet, Oslo

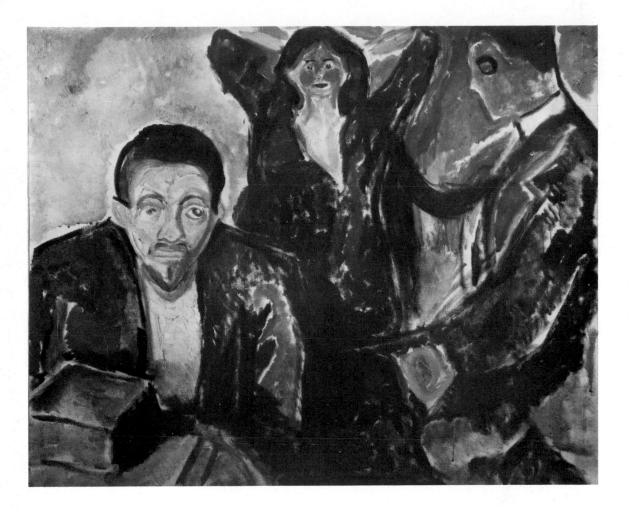

Figure 46. PASSION.
1913. Oil on canvas,
$29\frac{7}{8} \times 38\frac{5}{8}''$.
Munch-museet, Oslo

Figure 47.
Photograph of Munch
at Ekely, c.1938

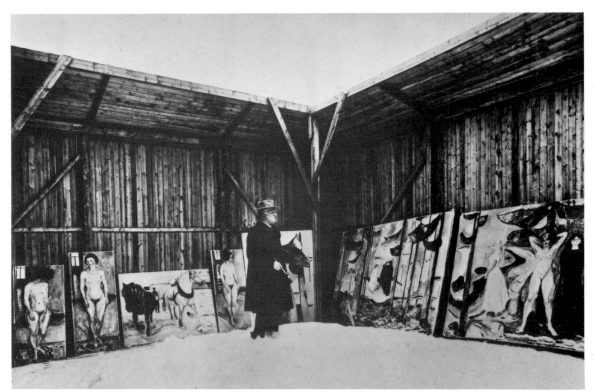

Figure 48. THE KISS. 1892. Oil on canvas, 28⅜ × 35¾″. *Nasjonalgalleriet, Oslo*

painters—the first generation of German artists for whom Expressionism came to signify a transitory movement rather than a broad and essentially timeless attitude. Not only did these younger men derive fundamental aesthetic principles from their illustrious precursor, but the fact that Munch was Norwegian, partaking of a Scandinavian vogue that prevailed in the cultural centers of Germany, made the "Genius from the North" a particularly timely model. It seems self-evident, from comparisons of their work, that Ernst-Ludwig Kirchner, Erich Heckel, Karl Schmidt-Rottluff, Max Pechstein, Emil Nolde, and the Austrian Oskar Kokoschka, who all came into their own in the first

decade of the twentieth century, owed much to the creator of *The Scream*. Munch had given form to many of their yearnings in paintings and prints predating their own emergence by almost fifteen years. He may therefore be considered, together with Gauguin and Van Gogh, as an eminent father figure to the Brücke group and to those associated with them at the time.

But Expressionism took unexpected turns as it developed. Particularly in the hands of Vasily Kandinsky, its main currents moved toward realizations that were alien if not in outright opposition to Munch's example. With the possible exception of Max Beckmann, whose pictorial thinking had more kinship with

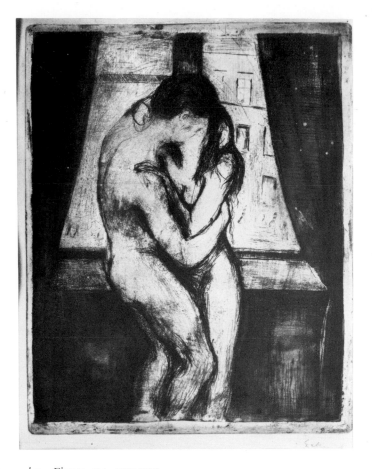

Munch's than the visible evidence suggests, most Expressionist painters after World War I moved away from him, thereby accentuating his essential isolation.

We therefore must conclude that Munch's relation to Post-Impressionism, from which he stems, and to German Expressionism, which to a large extent he fathered, suffers from an obliqueness that lies outside his work and is traceable to the unfathomable turns of stylistic developments. Perched between two plateaus far removed from each other, Munch was denied a full participating role in the vital Impressionist era and at the same time perhaps restrained as a lasting influence upon those who followed him. Within the large span of the modern era, therefore, the unforeseeable turns of subsequent historic currents have made Munch's art seem unduly muted.

Further and very special restraints on a true evaluation of Munch's full capacity as a painter are also exerted by the physical condition of his paintings, which, owing to his eccentric belief that paintings are best served by exposure to the elements, have in many cases suffered irreparable damage. Because of this the surfaces have in effect been devitalized. The subtlety

above: Figure 49. THE KISS. 1895. Drypoint, aquatint, and etching, 12⅞ × 10⅝". (Sch. 22/b)

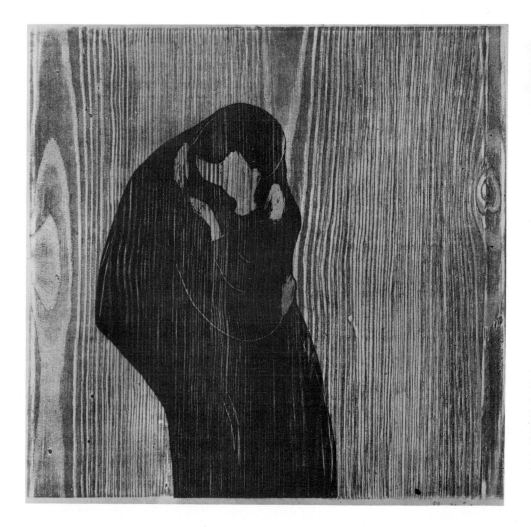

Figure 50. THE KISS. 1897–1902. Color woodcut, 18⅜ × 18⅜". (Sch. 102/D)

of the original color concept has often been toned down and deterioration of textural quality has in varying degrees reduced the original radiance. A painter who like Munch concerns himself above all with the totality of his work may be presumed to care less for the merely fragmentary existence of individual pictures. Convinced that he could always replace a missing link through new versions of equal quality—an assumption by no means borne out by the available evidence—Munch's attitude toward his paintings was far from protective. His remarkable print oeuvre therefore assumes additional significance as a faithful and undiminished carrier of his original material intention. If one considers the artist's extraordinary talent as a printmaker and his tendency to use etchings, lithographs, and woodcuts to perfect what in a sense was drafted in earlier painted versions, one could anticipate

that Munch's ultimate fame may rest most securely upon his many well-preserved masterpieces in the graphic mediums.

To admit the problematic nature of Munch's creative legacy is not to doubt his greatness. It was, let us repeat, a major achievement to revitalize sterile allegories about life and death and to find symbols and images that coincided with a timely awareness of the psychic dimension of man. Munch's fullblown and unabashed sentiment is as valid and as accessible today as the more recent Nordic ethos of Ingmar Bergman. Munch's grand vision—the themes that he projects with such power—remains, despite its nineteenth-century origin, a truthful and potent conveyer of reality.

Figure 51. WITHDRAWAL, VIGNETTE. 1902.
Etching and aquatint, $2 \times 3\frac{5}{8}''$. (Sch. 153/F)

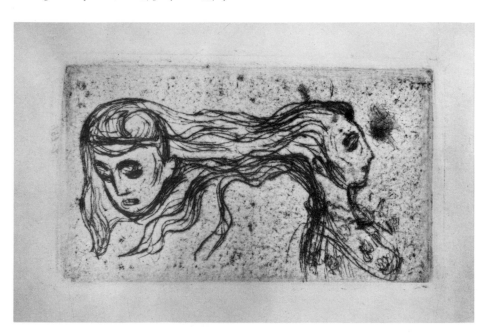

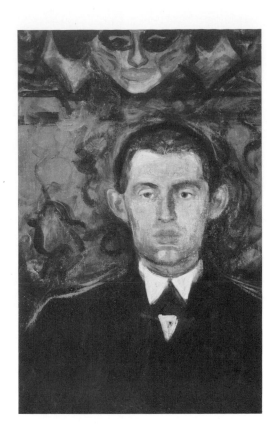

SELF-PORTRAIT
BENEATH THE MASK

Painted about 1892. *Oil on canvas,* 27⅛ × 17⅛"
Munch-museet, Oslo

Art is the form of the picture that has come into being through the nerves—heart—brain—and eye of man.

In this small but powerfully constructed half-portrait Munch shows himself in full frontality and slightly off center against an ornamental background pattern. Above him, a mask bearing feminine features looks out impassively from a central, commanding position.

The ethnic origin of the mask remains unknown, but its primitive or popular derivation raises the question of whether it was the kind that a decade later was to intrigue Picasso and the Brücke painters as these artists discovered a new formal relevance in exotic artifacts. The mask may also be the first image in Munch's work symbolizing aggressive femininity and, as such, a precursor of the Vampire (figs. 52–54) motif and of related themes. This early self-portrait seems to foretell much that is to come. Elements of Art Nouveau, Symbolism, and primitivism combine to make this one of the earliest European paintings to anticipate not only the great Munch works of the next decade, but many other features of the fin-de-siècle.

Although the artist is approaching thirty, his features

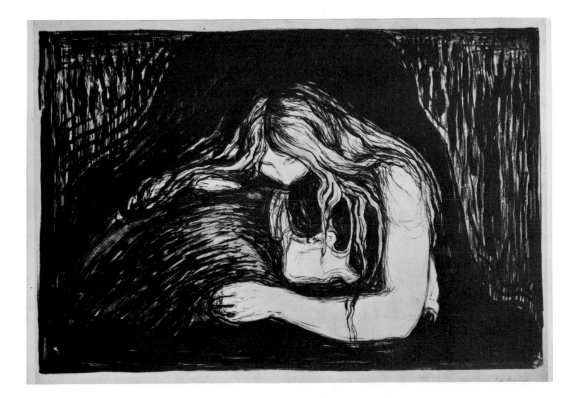

Figure 52.
VAMPIRE. 1895–1902.
Color woodcut and lithograph,
15¼ × 21⅜". (Sch. 34)

39

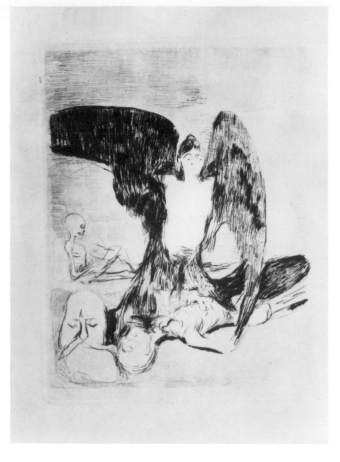

Figure 53. VAMPIRE. 1894.
Drypoint, 11⅝ × 8¾″. (Sch.4/IV)

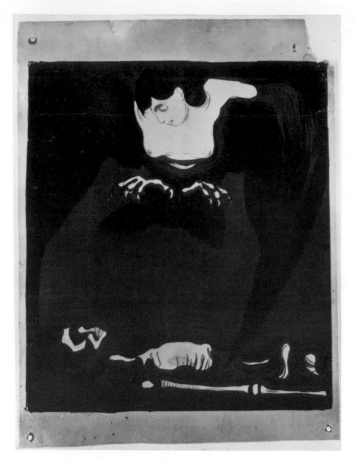

Figure 54. VAMPIRE (HARPY).
Color lithograph, 14⅜ × 12⅝″. (Sch.137/b)

are still those of a very young man. They reveal tension, sensuality, and dreamy introspection. Except for large and sharply angled ears, young Edvard is handsome and stylishly dressed.

The figurative subject matter, the artist and the mask, is held within a range from brown to yellow, while the decorative background provides the intermediary red. The resulting chromatic color scale produces a mood of somber intensity with ominous overtones.

The related woodcut *In the Man's Brain* (fig. 55) is also a telling example of many currents characteristic of Munch and his time.

Figure 55.
IN THE MAN'S BRAIN.
1897. Woodcut,
14¾ × 22⅜″. (Sch.98)

BIOGRAPHICAL OUTLINE

1863 Born December 12 at Engelhaugen Farm in Løten, Norway, son of Army Medical Corps doctor Christian Munch and Laura Catherine, nee Bjølstad. Edvard is the second of five children.

1864 Family moves to Oslo, then called Christiania.

1868 His mother dies of tuberculosis; his aunt, Karen Bjølstad, takes over the household.

1877 Munch's sister Sophie, aged 15, dies of tuberculosis.

1879 Enters the Technical College to study engineering.

1880 Begins to paint seriously; leaves the Technical College in November.

1881 Enters the School of Design, attending first the freehand and later the modeling class under the sculptor Julius Middelthun.

1882 Rents a studio with six fellow artists; their work is supervised by Christian Krohg.

1883 Included in first group exhibition in June at Oslo. In autumn, attends Frits Thaulow's "open air academy" at Modum.

1884 Becomes acquainted with the bohemian set, the avant-garde of contemporary Naturalistic painters and writers in Norway. Receives the first of several grants for continued studies.

1885 In May, on a scholarship from Frits Thaulow, travels via Antwerp to Paris, where he stays for three weeks. Visits the Salon and the Louvre; is especially impressed by Manet. Spends the summer at Borre and returns to Oslo to begin three of his major works: *The Sick Child*, *The Morning After*, and *Puberty*.

1889 First one-man exhibition in April, at Oslo. Rents a house at Aasgaardstrand for the summer. To Paris and environs in October, where he enters Leon Bonnat's art school. His father dies in November.

1886 Completes the first of several versions of *The Sick Child*. Munch is by now identified with the controversial group called Christiania-Bohème, after a novel by the anarchist Hans Jaeger.

1890 Continues to attend Bonnat's art school; moves primarily among Norwegian artists, poets, and writers. Spends the summer in Aasgaardstrand and Oslo. His state scholarship is renewed and in November he sails for France, but is hospitalized with rheumatic fever for two months in Le Havre. In December, five of his paintings are destroyed by fire in Oslo.

1891 Convalesces from January to April in Nice, then goes to Paris; returns to Norway for the summer. After third renewal of scholarship, again returns to Paris; in December, goes to Nice.

1892 Returns to Norway to arrange a large one-man exhibition at Oslo in September. On October 4, receives an invitation from the Verein Berliner Künstler to exhibit in Berlin. His paintings cause such violent protest that the exhibition is closed after one week. The German artists who support Munch, led by Max Liebermann, subsequently withdraw from the Verein and form the Berlin Secession. The exhibition is later shown at Düsseldorf and Cologne, returns to Berlin, then goes to Copenhagen, Breslau, Dresden, and Munich. Paints August Strindberg's portrait.

1893 Spends the greater part of his time in Germany until 1908, with visits to Paris and summers in Norway. Exhibits extensively in Germany, Paris, and Scandinavia. His friends include Strindberg, Richard Dehmel, Gunnar Heiberg, Julius Meier-Graefe, and the Polish poet Stanislaw Przybyszewski, who are associated with the periodical *Pan*. Works on the *Frieze of Life*; completes *Madonna, The Scream, Vampire,* and *Death and the Maiden.*

1894 Living in Berlin, he produces his first etchings early in the year, and later his first lithographs. First monograph on his work, *Das Werk des Edvard Munch*, by Przybyszewski, Meier-Graefe, Servaes, and Pastor. is published in July. Is introduced to Count Prozor, Ibsen's translator, and Lugné-Poë, director of the Théâtre de l'Oeuvre.

1895 Remains in Berlin until June, then goes to Paris. Meier-Graefe publishes a portfolio with eight Munch etchings. Late in June, travels to Norway via Amsterdam, and spends part of the summer at Aasgaardstrand. In September, returns to Paris; thence to Oslo for an exhibition (reviewed by Thadée Natanson in the November issue of *La Revue Blanche*). In December, *La Revue Blanche* reproduces the lithograph *The Scream*. Munch's brother Andreas dies.

1896 From Berlin to Paris in February. His friends include Frederick Delius, Meier-Graefe, Stéphane Mallarmé, Strindberg, and Thadée Natanson. Prints his first color lithographs and makes his first woodcuts at Clot's. Contributes the lithograph *Anxiety* to Vollard's *Album des peintres gravures;* makes a lithograph for the Théâtre de l'Oeuvre production of *Peer Gynt*. In May, works on illustrations for Baudelaire's *Les Fleurs du Mal*. Exhibits ten paintings at the Salon des Indépendants, April–May; his one-man show in June at Samuel Bing's gallery L'Art Nouveau is reviewed by Strindberg in *La Revue Blanche*. Goes to Norway in July, to Belgium in August, returns to Paris in the autumn.

1897 In Paris, exhibits ten paintings from the *Frieze of Life* at

Figure 56. Munch and Dr. Jacobson, 1908–9

the Salon des Indépendants and designs the program for *John Gabriel Borkman* at the Théâtre de l'Oeuvre. Spends the summer in Aasgaardstrand, where he buys a house; goes to Oslo in September.

1898 Continues to travel: in Norway; March to Copenhagen (exhibition) and Berlin; May in Paris (Salon des Indépendants); June in Oslo; summer in Aasgaardstrand; autumn in Oslo.

1899 Travel continues. In April via Berlin, Paris, and Nice to Florence; to Rome in May, then to Aasgaardstrand, Norstrand, and back to Aasgaardstrand; finally to a

sanitorium in Norway, where he convalesces during the autumn and winter.

1900 Leaves the sanitorium, visits Berlin, Florence, and Rome in March; then to a sanitorium in Switzerland; spends July in Como, Italy; autumn and winter in Norway. Completes *The Dance of Life*.

1901 Travels back and forth from Norway to Germany; spends the summer at Aasgaardstrand.

1902 Winter and spring in Berlin. Is introduced to Dr. Max Linde, who becomes his patron, purchases *Fertility*, and writes a book about him. To Norway in June, summer at Aasgaardstrand. At the end of an unfortunate love affair, loses the joint of a finger on his left hand from a gunshot wound. Visits Dr. Linde at Lübeck and is commissioned to make a portfolio of sixteen prints (*Linde Portfolio*). To Berlin in December, where he meets Gustav Schiefler, who buys several of his prints and starts a catalogue raisonné of his prints. Exhibits twenty-two works from the *Frieze of Life* at the Berlin Secession.

1903 Trip to Paris, where he exhibits at the Salon des Indépendants. Three visits to Lübeck; works on portraits of Dr. Linde and his four sons. Several stays in Berlin, a visit to Delius, summer at Aasgaardstrand.

1904 Concludes important contracts with dealers Bruno Cassirer in Berlin and Commeter in Hamburg for sole rights to sale of his paintings and prints in Germany. Becomes a regular member of the Berlin Secession, which Beckmann, Nolde, and Kandinsky join a year later. Continues to travel in Germany and Scandinavia; summer at Aasgaardstrand.

1905 Travels in Germany and Scandinavia. In spring, returns to Aasgaardstrand after a violent quarrel with the artist Ludvig Karsten (one of many quarrels with friends during this period). This incident is believed to have inspired two paintings of 1935, *The Fight* and *The Uninvited Guest*. Important exhibition at the "Mánes" Gallery, Prague.

1906–7 Spends time at several German spas; short trips to Berlin. Designs two Ibsen plays for Berlin presentations: *Ghosts* for Max Reinhardt's Kammerspiele, Deutsches Theater, and *Hedda Gabler* for Deutsches Theater. Paints a portrait of Friedrich Nietzsche at the request of Swedish banker Ernest Thiel, who subsequently commissions and purchases many of his oils.

1908 Winter in Berlin, with a short trip to Paris (exhibition) in February. Starts a series of pictures of workers. Jens Thiis, Director of Nasjonalgalleriet, Oslo, purchases several works for the museum over strong opposition. In the autumn, travels to Hamburg, Stockholm, and Copenhagen (exhibition), where he succumbs to a nervous breakdown (about October 1) and enters Dr. Jacobson's clinic.

1909 At the clinic, where he remains until spring, writes the prose-poem *Alpha and Omega*, which he illustrates with eighteen lithographs. Returns to Norway in May. In June, visits Bergen (exhibition), where Rasmus Meyers purchases several of his works. Begins design to be submitted to the competition for the decoration of the Oslo University Assembly Hall (Aula murals). In March, important exhibition at Blomqvist's in Oslo, consisting of 100 oils and 200 graphics. Paints landscapes and lifesize male portraits. Continues to travel.

1910 Winter and spring at Kragerø. Purchases the Ramme estate at Hvitsten on the Oslo Fjord to have more space for his work. Works on the Aula decorations.

1911 Lives at Hvitsten; brief visit to Germany. Spends autumn and winter at Kragerø. In August, wins the Aula competition and continues to work on the pictures.

1912 Is an "honorary guest" at the Sonderbund, Cologne; like Cézanne, Van Gogh, and Gauguin, given a room to himself. In December, is included in exhibition of contemporary Scandinavian art sponsored by the American Scandinavian Society, New York City. This is believed to be the first American showing of his work: among six oils are versions of *The Sick Child, Starry Night*, and *In the Orchard (Adam and Eve Under the Apple Tree)*. Spends the winter at Kragerø, and travels to Copenhagen, Paris (exhibition), Cologne (Sonderbund), Hvitsten; back to Cologne in September. Continues to work on the Aula pictures.

1913 Is represented in the Armory Show, New York City, by eight prints: versions of *Vampire, Moonlight, The Lonely Ones, Madonna*, and *Nude with Red Hair (Sin)*. Lent by the artist, they are priced at $200 each. Receives numerous tributes on the occasion of his fiftieth birthday. Rents Grimsrod Manor, Jeløya, to have more work space. Continues to travel: Berlin, Frankfurt, Cologne, Paris, London, Stockholm, Hamburg, Lübeck, and Copenhagen. In the autumn, alternates between Kragerø, Hvitsten, and Jeløya. In October, goes to Berlin (exhibition).

1914 Short trips to cities in Germany and Paris continued; returns to Norway in the spring. Oslo University accepts the Aula murals on May 29.

1915 At his third American show, *Panama-Pacific International Exposition*, San Francisco, is awarded a gold medal for graphics; ten oils are also exhibited. He is now successful enough to give financial aid to young German artists. Travel, confined to Scandinavia, has abated.

1916 In January, purchases the Ekely house at Skøyen, where he spends most of his time for the rest of his life. The Aula murals are unveiled on September 19.

1917 Curt Glaser's book *Edvard Munch* is published in Berlin.

1918 Writes brochure *The Frieze of Life* for an exhibition of the paintings at Blomqvist's in Oslo. Continues to work with Aula and *Frieze of Life* motifs.

1922 Paints twelve murals for workers' dining room in the Freia Chocolate Factory, Oslo. Retrospective exhibition of 73 oils and 389 graphics at the Kunsthaus, Zurich.

1923–27 Continues to support German artists. Receives various honors and exhibitions. Although travel has abated, he still makes frequent trips, mainly in Scandinavia and Germany. His sister Laura dies in 1926.

1927 Munch's most comprehensive show is held at the Nationalgalerie, Berlin, with 223 oils included. This exhibition is further enlarged and shown at the Nasjonalgalleriet, Oslo.

1928 Works on designs for murals for the Central Hall of the Oslo City Hall (project later abandoned).

1929 The "winter studio" at Ekely is built. Major graphics exhibition in the Nationalmuseum, Stockholm.

1930 Afflicted with eye trouble, which recurs for the rest of his life.

1931 Death of his aunt, Karen Bjølstad.

1933 Munch's seventieth birthday brings many tributes and honors. Books on him by Jens Thiis and Pola Gauguin published. Work on new designs for the *Alma Mater* in the Aula.

1937 Eighty-two of his works in German museums branded as "degenerate" and confiscated. These are later sold in Norway.

1940–44 Lives quietly during German occupation of Norway, refusing any contact with Nazi invaders and their collaborators. Continues painting and printmaking.

1944 On January 23, a little more than a month after his eightieth birthday, Munch dies peacefully at Ekely. He bequeaths all of his work to the city of Oslo: 1,008 paintings, 15,391 prints, 4,443 drawings and watercolors, and 6 sculptures. The Munch-museet is opened in 1963.

Figure 57.
A late photograph of Munch, c. 1938

SELECTED BIBLIOGRAPHY

BOOKS

BENESCH, OTTO. *Edvard Munch*. Translated by Joan Spencer. London: Phaidon, 1960. German edition, Cologne: Phaidon Verlag, 1960.

DEKNATEL, FREDERICK B. See Exhibition Catalogues

Edvard Munchs Brev: Familien (Oslo Kommunes Kunstsamlinger, Munch-museets Skrifter 1). Oslo: Johan Grundt Tanum Forlag, 1949.

Edvard Munchs brev fra Dr. Max Linde. Oslo: Dreyers Forlag, 1954.

Edvard Munch Mennesket og Kunstneren. Oslo: Gyldendal Norsk Forlag, 1946. Essays by Karl Stenerud, Axel L. Romdahl, Pola Gauguin, Christian Gierløff, N. Rygg, Erik Pedersen, Birgit Prestøe, Chrix Dahl, Johan H. Langaard.

Edvard Munch Selvportretter. Oslo: Gyldendal Norsk Forlag, 1947. Introduction by Johan H. Langaard.

Edvard Munch: Som Vi Kjente Ham. Oslo: Dreyers Forlag, 1946. Essays by K. E. Schreiner, Johs. Roede, Ingeborg Matzfeldt Løchen, Titus Vibe Müller, Birgit Prestøe, David Bergendahl, Christian Gierløff, L. O. Ravensberg.

GAUGUIN, POLA. *Edvard Munch*. Oslo: H. Aschehoug, 1933. Second edition 1946.
———. *Grafikeren Edvard Munch: Litografier*. Trondheim: Brun, 1946.
———. *Grafikeren Edvard Munch: Tresnitt og raderinger*. Trondheim: Brun, 1946.

GERLACH, HANS EGON. *Edvard Munch: Sein Leben und sein Werk*. Hamburg: Christian Wegner, 1955.

GIERLØFF, CHRISTIAN. *Edvard Munch selv*. Oslo: Gyldendal Norsk Forlag: 1953.

GLASER, KURT. *Edvard Munch*. Berlin: Bruno Cassirer, 1917.

GLØERSEN, INGER ALVAR. *Den Munch jeg Møtte*. Oslo: Gyldendal Norsk Forlag, 1956.

GREVE, ELI. *Edvard Munch: Liv og verk i lys av tresnittene*. Oslo: J. W. Cappelens Forlag, 1963.

HELLER, REINHOLD A. "Edvard Munch's Life Frieze: Its Sources and Origins." Unpublished Ph.D. dissertation, Indiana University, 1968.

HODIN, J. P. *Edvard Munch: Der Genius des Nordens*. Stockholm: Neuer Verlag, 1948. New edition, Mainz: Florian Kupferberg Verlag, 1963.

KOKOSCHKA, OSKAR. *Der Expressionismus Edvard Munchs*. Vienna: Gurlitt, 1953.

LANGAARD, INGRID. *Edvard Munch: Modningsaar*. Oslo: Gyldendal Norsk Forlag, 1960.

LANGAARD, JOHAN H. *Edvard Munch: Maleren*. Oslo: Nasjonalgalleriet Veileder IV, 1932.
——— and REVOLD, REIDAR. *Edvard Munch som tegner*. Oslo: Kunsten Idag, 1958. English edition, *The Drawings of Edvard Munch*. Oslo: Kunsten Idag, 1958.
———. *Edvard Munch: Auladekorasjonene*. Oslo: Forlaget Norsk Kunstreproduksjon, 1960. English edition, *Edvard Munch: The University Murals*. Oslo: Forlaget Norsk Kunstreproduksjon, 1960.
———. *Edvard Munch fra aar til aar. A Year by Year Record of Edvard Munch's Life*. Oslo: H. Aschehoug, 1961.
———. *Mesterverker i Munch-museet Oslo*. Oslo: Forlaget Norsk Kunstreproduksjon, 1963. English edition, *Edvard Munch*. Translated by Michael Bullock, New York-Toronto: McGraw-Hill, 1964.

LINDE, MAX. *Edvard Munch und die Kunst der Zukunft*. Berlin: F. Gottenheimer, 1902. Later edition 1905 (first edition contains original color woodcut).

MOEN, ARVE. *Samtid og Miljø*. Oslo: Forlaget Norsk Kunstreproduksjon, 1956. English edition, *Age and Milieu*. Oslo: Forlaget Norsk Kunstreproduksjon, 1956.

———. *Edvard Munch: Kvinnenog eros*. Oslo: Forlaget Norsk Kunstreproduksjon, 1957. English edition, *Woman and Eros*. Oslo: Forlaget Norsk Kunstreproduksjon, 1957.

———. *Edvard Munch: Landskap og dyr. Et Bildwerk*. Oslo: Forlaget Norsk Kunstreproduksjon, 1958. English edition, *Nature and Animals*. Oslo: Forlaget Norsk Kunstreproduksjon, 1958.

MOHR, OTTO LOUS. *Edvard Munchs Auladekorasjoner*. Oslo: Gyldendal Norsk Forlag, 1960.

Munch-bibliographi. Oslo: Oslo Kommunes Kunstsamlinger, Aarboker, 1951, 1952–59, 1960, 1963. Yearbooks containing detailed bibliographies by Hannah B. Muller and Reidar Revold.

PRZYBYSZEWSKI, STANISLAW, ed. *Das Werk des Edvard Munch*. Berlin: S. Fischer Verlag, 1894. Contributions by Stanislaw Przybyszewski, Franz Servaes, Willy Pastor, Julius Meier-Graefe.

SARVIG, OLE. *Edvard Munchs Grafik*. Copenhagen: J. H. Schultz Forlag, 1948. New edition, Copenhagen: Gyldendal, 1964. German edition, Zurich-Stuttgart: Flamberg, 1964.

SCHIEFLER, GUSTAV. *Verzeichnis des graphischen Werks Edvard Munchs bis 1906*. Berlin: Cassirer, 1907.

————. *Edvard Munch: Das Graphische Werk 1906–1926*. Berlin: Euphorion Verlag, 1928.

STENERSEN, ROLF E. *Edvard Munch: Naarbild av ett geni*. Stockholm: Wahlstrom & Widstrand, 1944. Enlarged edition, Oslo: Gyldendal Norsk Forlag, 1946.

THIIS, JENS. *Edvard Munch og hans samtid*. Oslo: Gyldendal Norsk Forlag, 1933.

TIMM, WERNER. *The Graphic Art of Edvard Munch*. Translated by Ruth Michaelis-Jena with the collaboration of Patrick Murray. Greenwich, Conn.: New York Graphic, 1969.

WILLOCH, SIGURD. *Edvard Munchs Raderinger* (Oslo Kommunes Kunstsamlinger, Munch-museets Skrifter 2). Oslo: Johan Grundt Tanum Forlag, 1950.

ARTICLES

HOFFMANN, EDITH. "Some Sources for Munch's Symbolism," *Apollo* (London), LXXXI, February 1965.

SMITH, JOHN BOULTON. "Portrait of a Friendship: Edvard Munch and Frederick Delius," *Apollo* (London), LXXXIII, January 1966.

STRINDBERG, AUGUST. "L'Exposition d'Edvard Munch," *La Revue Blanche* (Paris), X, June 1896.

EXHIBITION CATALOGUES
(chronologically arranged)

NEW YORK, MUSEUM OF MODERN ART in collaboration with INSTITUTE OF CONTEMPORARY ART, BOSTON. *Edvard Munch*. 1950. Essay by Frederick B. Deknatel, introduction by Johan H. Langaard, bibliography by Hannah B. Muller.

NEW YORK, THE SOLOMON R. GUGGENHEIM MUSEUM. *Edvard Munch*. October 1965–January 1966. Texts by Sigurd Willoch, Johan H. Langaard, Louise Averill Svendsen.

LOS ANGELES COUNTY MUSEUM OF ART. *Edvard Munch: Lithographs, Etchings, Woodcuts*. January 28–March 9, 1969. Introduction by William S. Lieberman, notes by Ebria Feinblatt.

WASHINGTON, D.C., THE PHILLIPS COLLECTION. *The Work of Edvard Munch*. 1969. Introduction by Alan M. Fern, catalogue notes by Jane Van Nimmen.

COLORPLATES

PORTRAIT OF THE ARTIST'S SISTER INGER

Painted 1884. *Oil on canvas,* 38¼×26⅜"
Nasjonalgalleriet, Oslo

This early three-quarter-length portrait is rendered within the limits of a prevailing academic tradition. The artist's sister Inger is shown in half-profile wearing a dark dress buttoned up in front and lightly embroidered on the sleeves. A simple necklace with a metal cross adds another discreetly ornamental touch. Face and hands emerge conspicuously against a uniformly somber background. A rigid self-consciousness in the sitter's expression and posture may well reflect the artist's own emotional immaturity at the time. However, the barely twenty-year-old Munch is already in possession of a creditable technical command and clearly grasps the inherent problems of portraiture. Inger's strongly modeled head is a close likeness, conforming to the requirements of nineteenth-century portraiture. At the same time, the dramatic emergence of the central features results in an abstract solution that shows Munch's awareness of the portrait's simultaneous commitment to a purely pictorial order.

Sometimes clearly recognizable, sometimes half disguised, the likeness of his sister Inger recurs repeatedly in Munch's early work, notably in the many versions of the *Chamber of Death* (colorplate 8). The most important painting of his sister is the large oil, *Inger Munch,* of 1892 (colorplate 7).

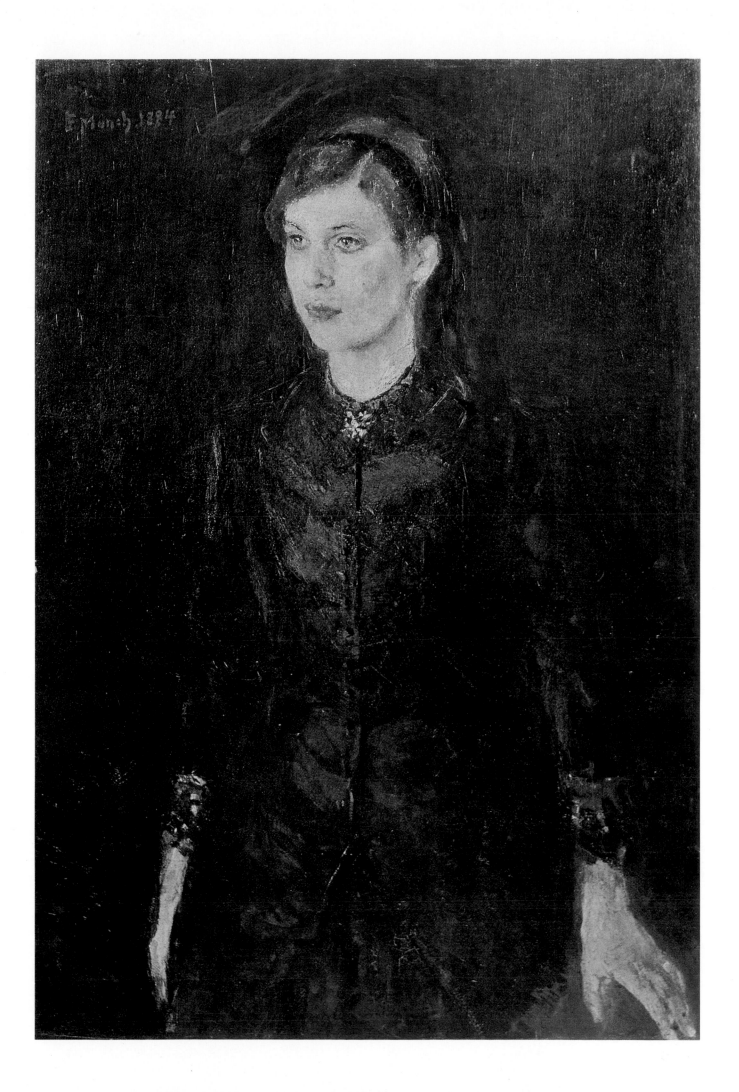

COLORPLATE 2

THE SICK CHILD

Painted 1885–86. Oil on canvas, 47 × 46¾"
Nasjonalgalleriet, Oslo

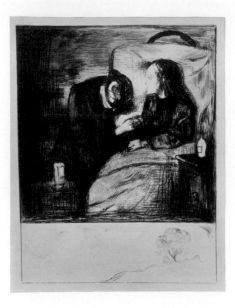

Figure 58.
THE SICK GIRL. 1894.
Drypoint and roulette,
14¼ × 10⅝".
(Sch. 7/V/d)

With The Sick Child, *I opened up new paths for myself—it became a breakthrough in my art. Most of my later works owe their existence to this picture.*

With its free brushstrokes deployed in shallow space, *The Sick Child*, more than other paintings of the same period, is a harbinger of Expressionism. The work invites comparison with the later *Spring* (colorplate 3), of comparable subject matter, which, however, remains firmly within a Naturalist, nineteenth-century mode. The personages in both paintings are similarly cast, but the earlier patient shows a childlike profile, while the girl in *Spring* is a teen-ager. The older woman, her head lowered in silent despair (which brings into full view the characteristic bun), is the same in both works and is identifiable as Munch's aunt, Karen Bjølstad.

The textural effects are exceptionally significant in this work. Crusty and rough, scratched and dented

throughout, the surfaces complement one another from within to enhance the painting's content through the materials and their application. The textural energy thus expended seems to invigorate the subject and thereby the intensity of the work as a whole. It was no doubt some such enhancement that Munch meant to bring about through the deliberate manhandling of his canvases. If so, the attainment of his goal in instances like this must be balanced against the loss of vitality and clarity, which generally sapped rather than nourished the surfaces of his paintings.

The Sick Child is one of the most persistent motifs in Munch's imagery. Painted versions may be seen at the Goeteborg Museum (1896), the Tate Gallery (1906–7), Thielska Galleriet in Stockholm (1907), and at the Munch-museet (c. 1926–27). While all these retain their compositional closeness to the prototype of the 1880s, later versions assume an increasingly Expressionist flavor through Munch's reliance on crass color contrasts. The same evolution from a merely insinuated to a fully articulated Expressionism may be observed by comparing the early drypoint of 1894 with any of the lithographic series of profiles and an etching executed two years later (figs. 58–60).

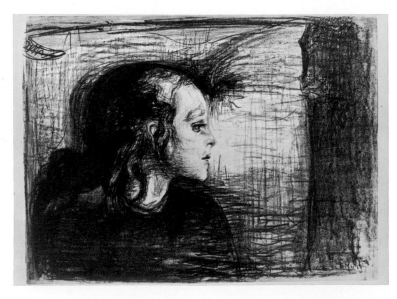

above: Figure 59. THE SICK GIRL. 1896.
Color lithograph, 16½ × 22¼". (Sch.59)

right: Figure 60. THE SICK GIRL. 1896.
Etching and drypoint, 5 × 6⅝". (Sch.60)

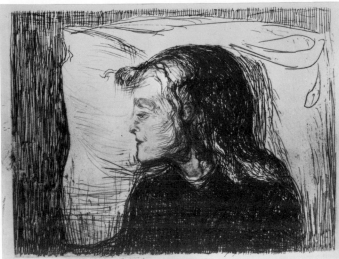

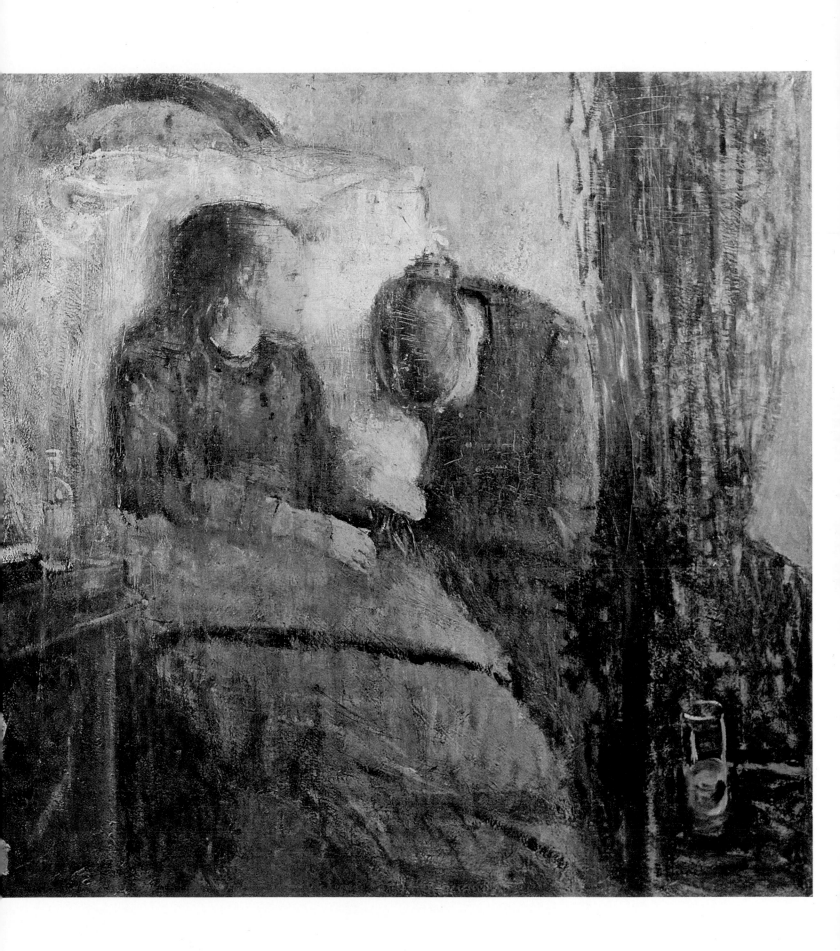

COLORPLATE 3

SPRING

Painted 1889. Oil on canvas, 66½ × 103⅞"
Nasjonalgalleriet, Oslo

We should stop painting interiors with people reading and women knitting. We should paint living people who breathe and feel and suffer and love.

Spring is Munch's first self-conscious masterpiece, with which he completes his apprenticeship much as Matisse did eight years later with his prize-winning *Dinner Table*. It is Munch's largest early canvas and was clearly intended as a chef d'oeuvre by the twenty-six-year-old painter.

The subject, as in so many of his youthful works, is sickness, a condition that Munch knew all too well from firsthand experience. The suffering figure of the frail patient is surrounded by interior gloom. By contrast, springtime with its implication of health literally blows through the white gauze of the curtain fabric. The narrative content centers on the sick girl and her knitting attendant—the respective carriers of sickness and health. The ruddy complexion of the older woman is exaggerated to point up the deathly pallor of the stricken girl. Objects reinforce the same contrasts: table, desk, and chest, all rendered with Chardinesque

care, become mute witnesses to the somber occasion, while the potted plants on the windowsill partake of spring as they lend their tender hues to the billowing curtains. The grays and browns of an already conventional Naturalism contrast with the light tonalities of the Impressionist mode. The resulting dualism almost rends the work into two separate parts. The plausible distinction between interior and exterior runs parallel with an obvious symbolism that equates darkness with sickness and light with life. Eventually, the juxtaposition creates a stylistic parable as Munch intuitively identifies the aging idiom of Naturalism with the melancholy content of the work while reserving his exploration of Impressionism for its optimistic connotations.

While there are no other works that repeat *Spring* in its entirety, a small oil at the Munch-museet dated c. 1888 and titled *Noonday Rest* (fig. 61) foretells the later, major work in some of its details. An old man's siesta here takes the place of the central theme in *Spring*, but the knitting attendant, the plants, the windowsill, and the swaying curtains are already fully developed.

Figure 61. NOONDAY REST. c.1888.
Oil on canvas, 13⅝ × 18½".
Munch-museet, Oslo

MILITARY BAND ON KARL JOHAN STREET, OSLO

Painted 1889. Oil on canvas, 40⅛×55¾″
Kunsthaus, Zurich

When a military band came down Karl Johan Street one sunlit spring day, my mind was filled with festival—spring—light—music—till it became a trembling joy—the music painted the colors.—I painted the picture and made the colors vibrate in the rhythm of the music—I painted the colors I saw.

Karl Johan Street, or Karl Johan Gate as the Norwegians call it, is Oslo's main avenue. It issues from the city's center, passes the Parliament building, skirts the Municipal Park on the one side and the University on the other, and then heads upward to the Castle, the seat of Norway's kings. Today the street is covered with cobblestones and serves as a busy artery for two-way traffic. Munch was drawn to Karl Johan Street repeatedly in his paintings and prints, and devoted to it such canvases as *Spring Day on Karl Johan Street, Oslo* (colorplate 6) and the subsequent *Evening on Karl Johan Street* (colorplate 9), among many others.

In *Military Band on Karl Johan Street, Oslo* the sunny boulevard with big puddles glistens after a spring shower. A brass band marches down the avenue, which is given its full length while its width is exaggerated in order to achieve depth through gradually converging sidelines. Spruced up for the occasion, Oslo's townsfolk stroll along, watch from the sides, or cross the street ahead of the approaching marchers. The canvas is held to the light tonalities of early Impressionism. Manet

more than other models comes to mind, partly because of the relative unity of the surface and its reliance upon tonal harmonies rather than fragmented color, but also because Munch blurs his descriptive outlines as Manet or, for that matter, Goya did before him.

In this version of the Karl Johan Street theme Munch takes some liberties with the subject matter. He omits the existing tree rows which he records so faithfully in other paintings of the same scene. The central three-story building with projecting shutters, on the contrary, is rendered with such precision that a visitor to the same spot over eighty years later will not find significant changes.

A detail that commands special attention is Munch's rendition of the two women crossing the street. Their contours, distinct from others in the same work, are ornamental and highly stylized, as if it had been the artist's intention to transform human beings into musical instruments—girls into cellos. Such isolated Art Nouveau accents are indicative of a gradually changing sensibility that will assert itself fully in Munch's work three years later. The sharply cut-off profile head of a boy, which is projected dramatically against a red parasol at the extreme lower right of the canvas, is an interesting technical device. Such extreme forward thrusts, already foreshadowed by Degas, were later used by Munch in *Jealousy* (colorplate 18), *The Red Vine* (colorplate 22), and others.

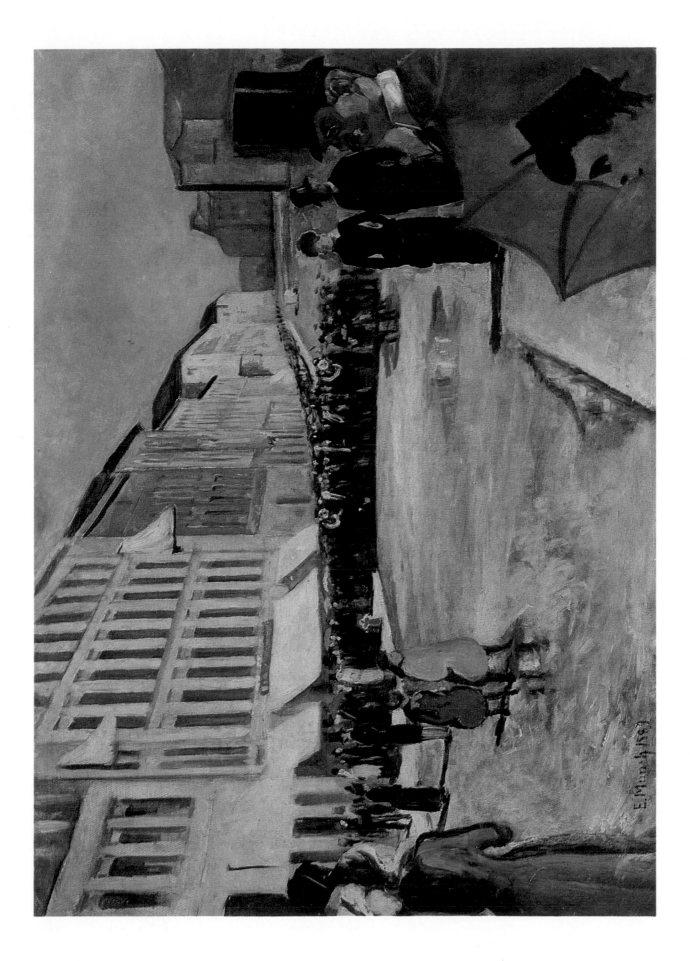

RUE LAFAYETTE

Painted 1891. Oil on canvas, 36¼ × 28¾"
Nasjonalgalleriet, Oslo

Through its subject matter, its optimistic mood, and the adoption of the Impressionist mode, this Parisian street scene announces its closeness to French models. Since Munch lived on the Rue Lafayette during the spring of 1891—the year he signed and dated this work—the scene cannot be divorced from autobiographical overtones.

A gentleman, fashionably dressed, leans over the railing of a balcony to observe the busy flow of traffic that converges from various directions on a star-shaped Parisian square. In Impressionist fashion, Munch achieves a simultaneous functioning of the painted surface as carrier of a specific subject and as conveyor of an abstract coloristic order. To this end, outlines maintain their descriptive capacity but are blurred to preserve the independent identity of the separate brushstrokes. The shapes of horse-drawn carriages, of pedestrians crossing the street, and of the buildings lining the square must assert themselves through amorphous application of pigment. This they do with spontaneous intensity, as if a shower of paint falling diagonally on the street were allowed to form purposeful blotches through which a pictorial order as well as an explicit meaning could come to the fore.

Munch's dependence upon Impressionism is incontestable, but an ever-present emotional dimension comes to the surface in such details as the balcony railing which, with hindsight, can be recognized as a prototype for similar props in *Girls on the Jetty* (colorplate 23) or *The Scream* (colorplate 13). Stylistically, the ornamental pattern, with its expressive convolutions painted in mauve, red, and brown, seems like the first portent of a newly emerging Art Nouveau sensibility. Like the atypical delineation of the two women in *Military Band on Karl Johan Street* (colorplate 4), these arabesques, mirrored for added emphasis in their own shadows, contrast starkly with the Impressionist strokes of color that hold sway in the Parisian street scene below.

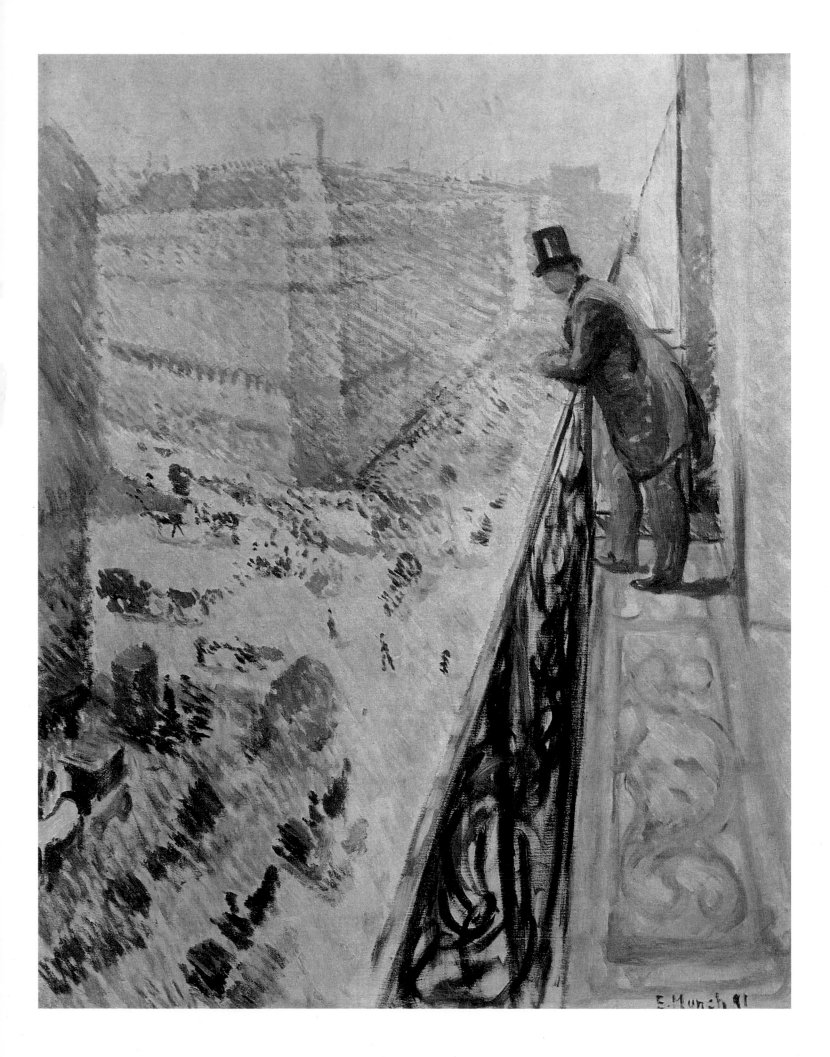

SPRING DAY ON KARL JOHAN STREET, OSLO

Painted 1891. *Oil on canvas,* $31\frac{1}{2} \times 39\frac{1}{2}''$
Bergen Billedgalleri

Karl Johan Street, Munch's principal motif in Oslo, is shown here in its fullest expanse even though perspective devices are somewhat curtailed by an Impressionist deemphasis of line and a corresponding flattening of surface. Mat and glistening textures, blues and violets structure the canvas. The blues form pronounced accents along the long row of rooftops and receive further emphasis when applied to the lines of advancing pedestrians. The same dominant color is also reserved for the averted solitary figure that commands the foreground like an inverted exclamation point.

Sensibilities traceable to various moments in Munch's development meet meaningfully in this work. Another,

obviously earlier oil (fig. 63) of the same scene and a sketch for this version (fig. 62) are both related to *Military Band on Karl Johan Street* (colorplate 4). Comparison of these versions with one another provides interesting insights into Munch's growing capacity to structure his works. The positioning of three girls in the lower right corner is a device exploited further in subsequent works. Here the artist introduces the trio marching cheerfully and energetically into the picture space, imbuing it with Renoiresque tenderness and dissolving the feminine outlines in the surrounding light. At the same time, the deliberate orchestration of the surface, a mark of Neo-Impressionism, asserts itself through the paint-flecked structure. Finally, an early hint of the mysterious in Munch's inward-oriented art is furnished by the conspicuous anonymity of the parasol-shielded personage who appears to address herself to two lengthening shadows entering her field of vision from the left. Although the emotional implications of such an encounter are here lessened by an inherited style, the confrontation clearly foretells the mysterious encounter between woman and shadow in *Moonlight*, executed two years later (colorplate 12).

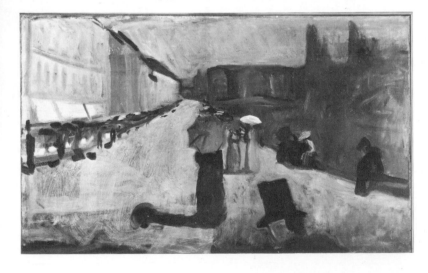

above: Figure 62. SKETCH FOR SPRING DAY ON KARL JOHAN STREET.
1889. Oil on canvas, $20 \times 32\frac{1}{8}''$. *Munch-museet, Oslo*

right: Figure 63. RAINY DAY ON KARL JOHAN STREET.
1891. Oil on canvas, $15 \times 21\frac{5}{8}''$. *Munch-museet, Oslo*

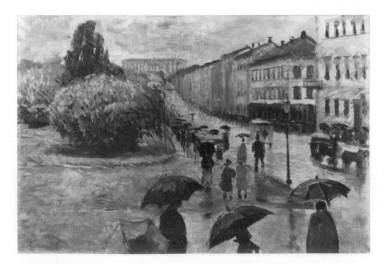

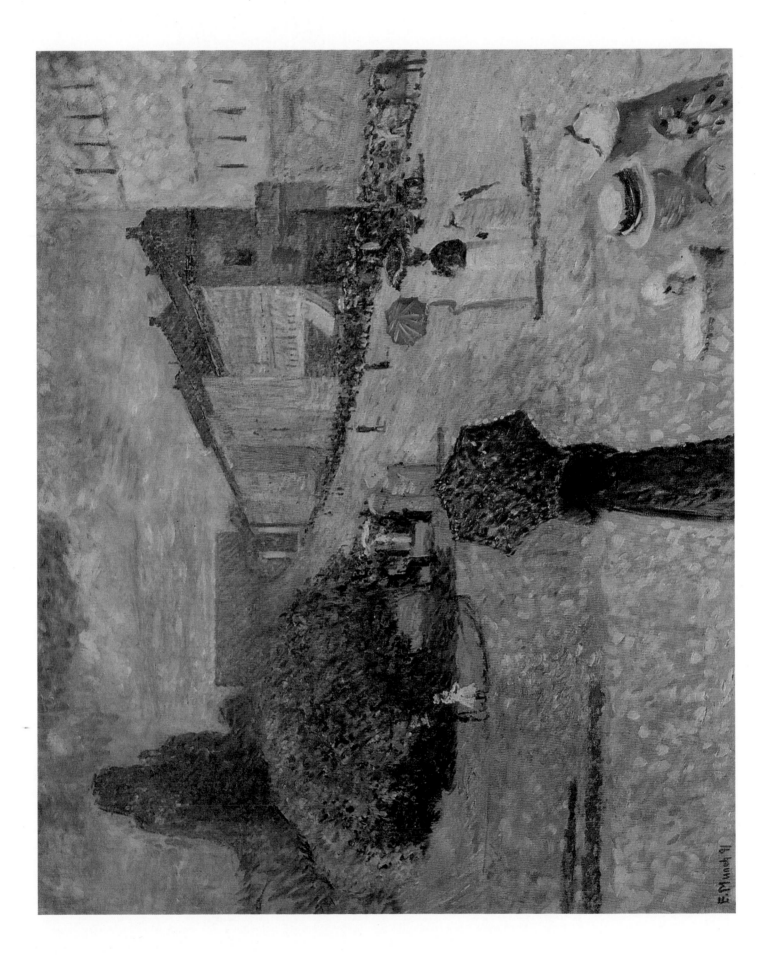

COLORPLATE 7

INGER MUNCH

Painted 1892. Oil on canvas, 67¾×48¼″
Nasjonalgalleriet, Oslo

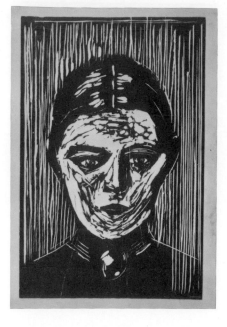

Figure 64.
INGER MUNCH
AS A YOUNG GIRL.
c.1926. Woodcut,
12¾×8¾″

I felt I should do this—it would be so easy!—The flesh would take shape and the colors live.—

Inger Munch stands erect and column-like in a vacuum, isolated from events and emotions. Her oval head emerges from a close-fitting collar with almost geometric precision and neatness. Her clasped hands create a posture that Munch often used in subsequent work. Contained within a prominent outline, Inger stands on a warm red-brown surface and is projected against a light blue wall. Her dark, patterned dress is consonant with these tonalities and avoids the disturbing clashes that are precipitated in the agitated *Chamber of Death* (colorplate 8), into which the portrait of Inger Munch was later transferred.

In 1892 Munch's painting assumes the characteristics for which we know him today. A year of transition, it yielded Impressionist canvases such as *Woman Fixing Her Hair* (fig. 65). But the broken brushstrokes in such works develop plausibly into streaked surfaces, as in *The Sick Child* (fig. 66), and then into flat color contained within heavy outlines, as in *Inger Munch*.

Close in expressive treatment to *Self-Portrait Beneath the Mask* (frontispiece), Inger's features are marked by a similar concentration and tension, and by the same unequivocal frontality that characterizes Munch's youthful portrait of himself. By comparison with the earlier *Portrait of the Artist's Sister Inger* (colorplate 1), the likeness of 1892 is distinguished by a lack of self-consciousness and the absence of a pose. During the eight years that have passed between the artist's attention to this model he has not only advanced toward the creation of an individual style, but in the course of this very maturing process has attained a measure of detachment that reflects itself in the features and the demeanor of his models.

left: Figure 65. WOMAN FIXING HER HAIR. 1892.
Oil on canvas, 36×28⅜″. *Rasmus Meyers Samlinger, Bergen*

below: Figure 66. THE SICK CHILD. 1892.
Oil on canvas, 21⅜×28⅝″. *Rasmus Meyers Samlinger, Bergen*

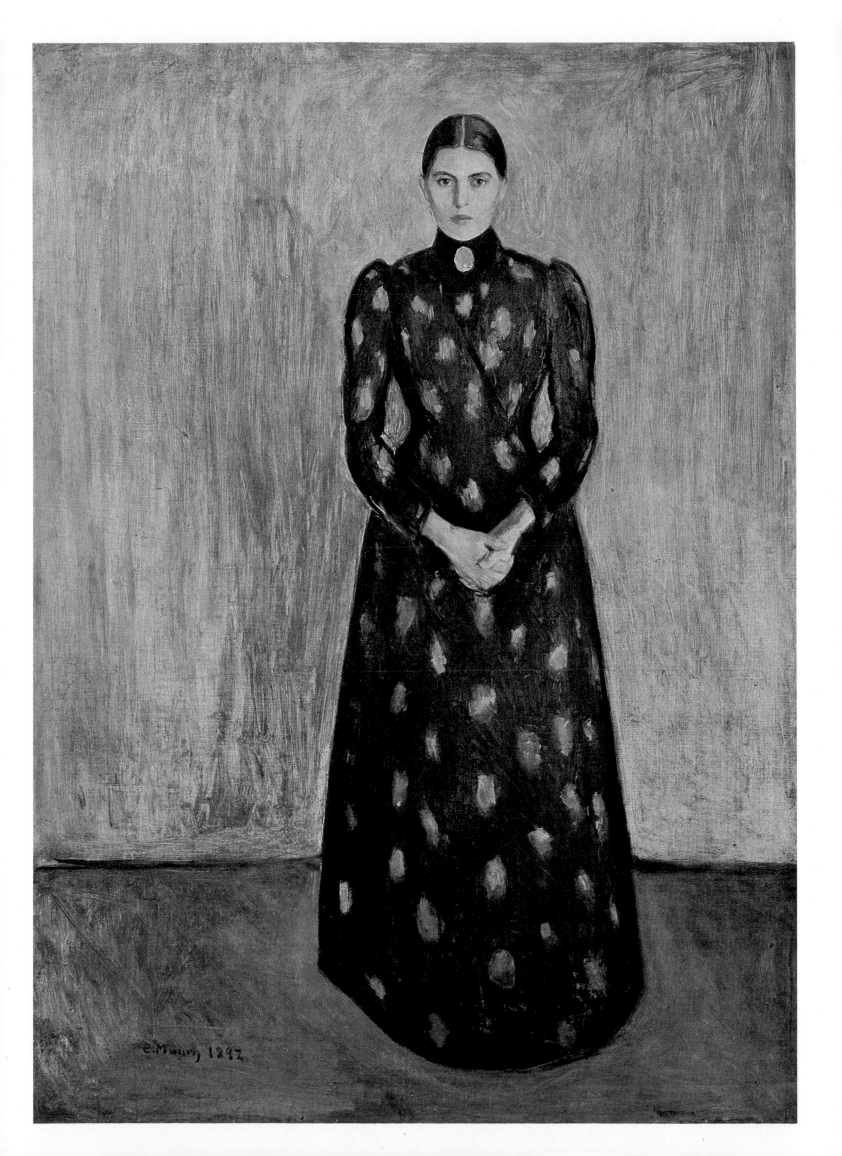

COLORPLATE 8

CHAMBER OF DEATH

Painted about 1892. Oil on canvas, 59 × 66"
Nasjonalgalleriet, Oslo

Edvard Munch was five years old when his mother died of tuberculosis, and fourteen when his sister Sophie succumbed to the same illness. There can be little doubt that these events had a traumatic effect on the sensitive child, whose health was also fragile. The artist's pre-occupation with deathbed scenes may well stem from a desire for catharsis—from a need for relief from emotional pressures through the act of visualization.

The work reproduced here is the most relentless of the many *Chamber of Death* versions. The room is sealed off from the outside and becomes for the enclosed Munch family a living tomb. A high chair with oval backrest, possibly the one that held the patient in *The Sick Child* (colorplate 2) and in *Spring* (colorplate 3), reappears as a focal point for the six dramatis personae

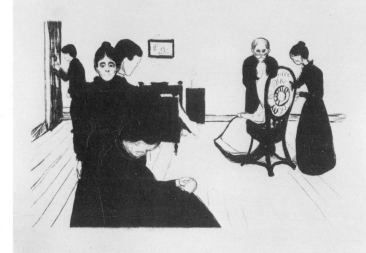

Figure 68. THE DEATH CHAMBER. 1896. Lithograph, 15 ¼ × 21 ⅝". (Sch.73)

who turn to and from it in the moment of calamity. There is no need to show more than a partially concealed quarter view of the dying woman, since death is written into the postures and features of the mourning survivors. Munch stands with his back to his sister Inger, who appears in the same frontal statuesque position in which she is rendered in the lifesize portrait of 1892 (colorplate 7). In both works, which usually hang in close proximity at Oslo's Nasjonalgalleriet, Inger wears the same dress and holds her hands clasped before her. The changes in her later likeness are significant, however. Where Inger was composed and meticulously groomed, she now becomes an image of red-eyed and hollow-cheeked despair as she is caught in the tense moment before a fresh outburst of tears. The color of the conspicuously patterned dress has been lightened and dulled, as has the face, resulting in a color scheme that is muted but far from gentle. The artist allows browns, blues, and greens to strike a jarring chord, while admitting other tonalities sparingly. Munch's line in this remarkable work curves and swirls all the more violently for being confined within a straight and deep picture space delineated by the chamber itself. Technical brilliance is no longer a prime objective, however. Nor does Munch approach his subject with an outwardly descriptive aim as he still did in *Spring*. Instead, he renders the death experience itself in its relentless intensity.

Versions abound in all media. In a preliminary drawing Inger's arms are held stiffly at her sides (fig. 67). The most important variations are *Death in a Sickroom* of 1892, at the Munch-museet, and a lithograph of 1896 which follows closely the painting discussed (fig. 68).

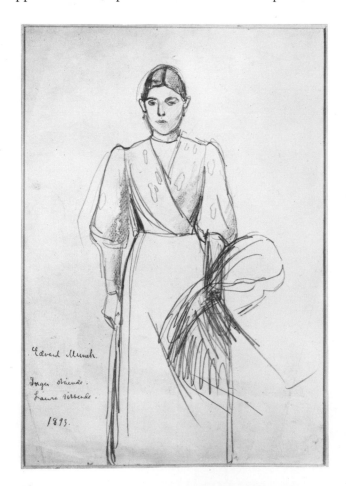

Figure 67. STUDY FOR THE DEATH CHAMBER. 1893. Pencil, 27 × 15". The inscription reads: Inger standing. Laura sitting.

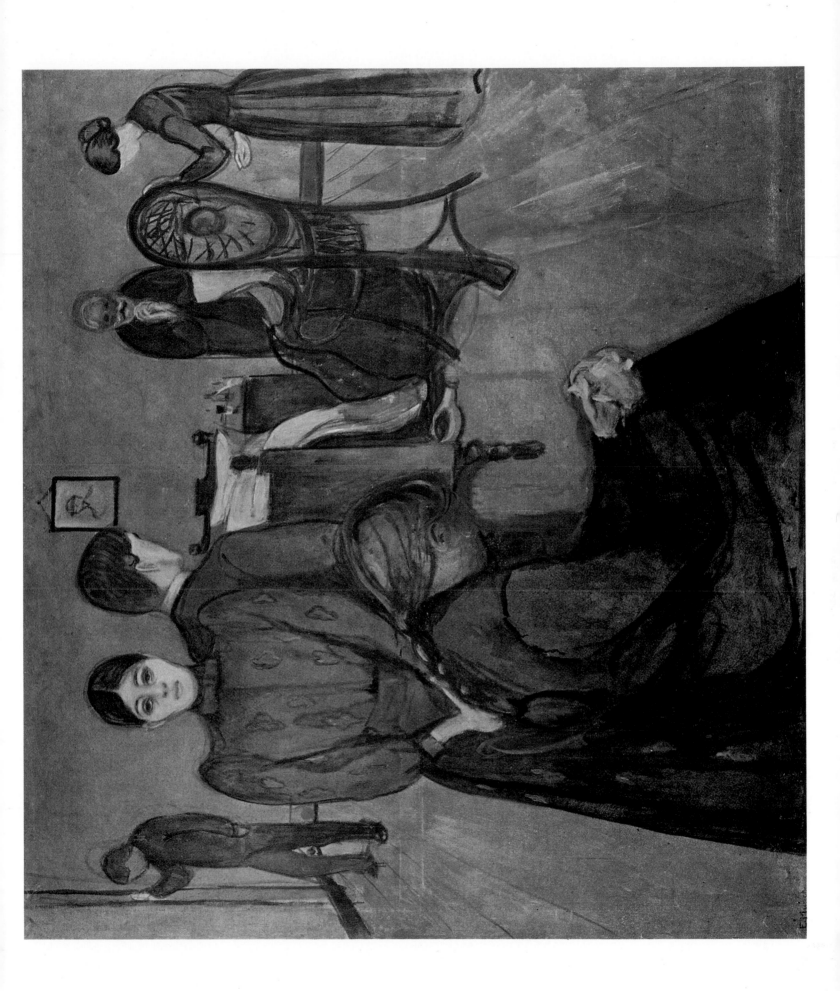

EVENING ON KARL JOHAN STREET

Painted about 1892. *Oil on canvas,* 33¼×47⅝″
Rasmus Meyers Samlinger, Bergen

The themes and moods of the various panels, [Frieze of Life] *sprang directly from the controversies of the eighties and constitute a reaction against the Realism then prevalent.*

The same Karl Johan Street in Oslo that Munch had painted in 1889 in the manner of early Impressionism, and later in the techniques of Pissarro and Seurat, reappears shrouded in the gloom of night as a pictorial analogy of an emotionally charged and anxious state of mind. As has been stated before, 1892 is the beginning of Edvard Munch's emergence as an artist of lasting consequence. Had he died three years before, Norway would have lost its white hope among painters, and we would not know his name. Even in 1890 and 1891, when Munch's attainments could be measured by Parisian (i.e., international) standards, the inherited Impressionist idiom, although transformed from within, overshadowed his own contribution. By 1892, however, through such works as *The Kiss* (fig. 48), *Self-Portrait Beneath the Mask* (frontispiece), and *Evening on Karl Johan Street* among others, Munch's personal style stands before us complete and clearly distinguishable from the generalized flourishes attributable to the age as a whole.

Evening on Karl Johan Street seems to plunge the artist back into the provincial gloom of the northern capital, back into Nordic obsession with man's mortality and loneliness. Essentially a small town even today, Oslo must have seemed a comedown from the metropolitan spectacle that had surrounded the young artist during his years abroad. But the harbor town, with its hazy lights and its melancholy ambiance, may have helped to evoke the inward reality that now began to substitute itself for the color veil of appearances.

Munch in 1892 exercised the kind of critique upon the Impressionist premise that Cézanne, Seurat, Van Gogh, and Gauguin—each in his own way—had already embarked on before him. It was, in one word, a rejection of an optically predicated vision in favor of one concerned with underlying currents. By finding new and unique ways to render visible the transformation from an already somewhat worn to a fresh and acute sensibility, Munch in 1892 became the last of the great Post-Impressionists.

A pencil study (fig. 69) is evidence that Munch's decision to move the figures up to the picture plane in the finished oil also contributed to the emotional impact he desired.

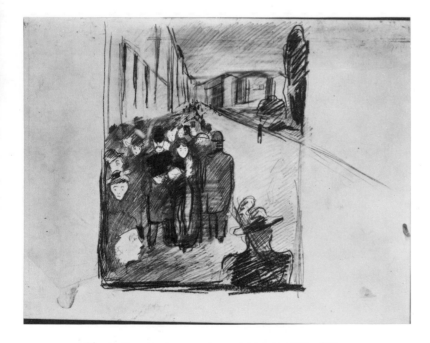

Figure 69. EVENING ON KARL JOHAN STREET. 1892.
Pencil and crayon, 13¼×10″. *Munch-museet, Oslo*

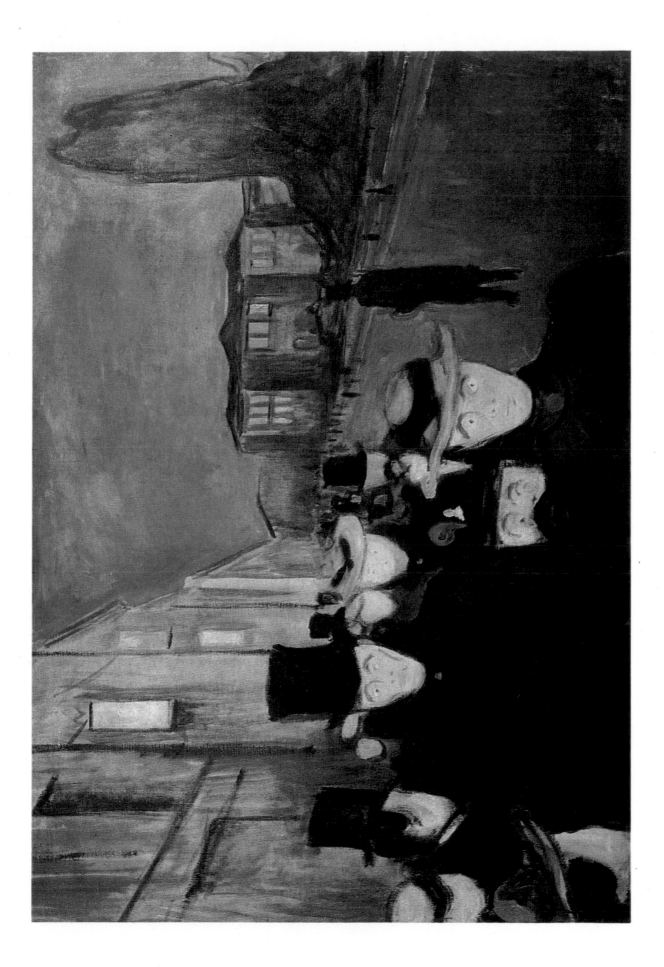

DEATH AND THE MAIDEN

Painted about 1893. Oil on canvas, $50\frac{3}{8} \times 33\frac{7}{8}''$
Munch-museet, Oslo

The camera cannot compete with brush and palette—as long as it cannot be used in hell or heaven.

Munch introduces the skeletal figure of Death, in all his hollow-eyed medieval horror, without self-consciousness and without irony. Death takes his place naturally among men and women. Departing from the Kiss motif, first seen in an oil in 1892 and continued through many variants thereafter, *Death and the Maiden* strikes the ancient romantic strain of love and death with new force, transforming the medieval reality into a poetic metaphor revitalized by contemporary insight. Munch in this burdened theme does not accept the traditional relationships, but instead suggests something of a victory of love over death by making the maiden, rather than the ravisher of old, exert the fatal pressure as she clasps Death's yielding bones to force the ultimate consummation. As her sensuous flesh is penetrated in the death embrace, new life, symbolized by marginal embryos, emerges in gray and angular ugliness. The life force, personified through a sexually aggressive femininity, asserts itself here as it does in the related Vampire motifs, and in other visions of women that Munch conceived throughout his mature years.

Death in his skeletal embodiment is a frequent visitor to Munch's attenuated inner world. He is not always endowed with fearful attributes. In a lithograph, *Self-Portrait—Dance of Death*, Munch tinkered with the Great Leveler's bones, as if he were engaged in the detonation of a time bomb. The print that follows most closely the painting here under discussion is the drypoint *The Maiden and Death* (fig. 70), completed in 1894, a year after the original conception had been executed in oil. As in other

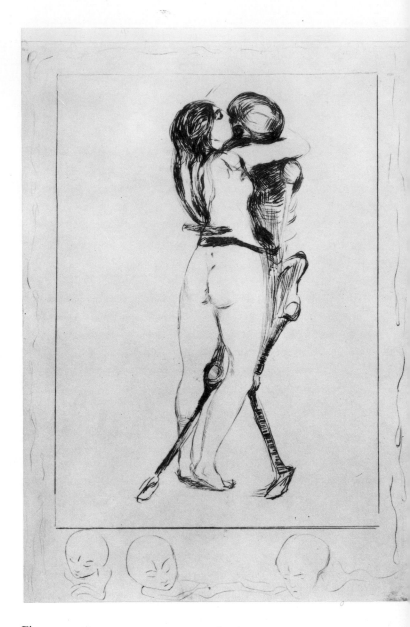

Figure 70. THE MAIDEN AND DEATH. 1894. Drypoint, $11\frac{1}{2} \times 8\frac{1}{2}''$. (Sch.3/II/b)

such instances, the imagery becomes clearer and more explicit in subsequent print mediums. Paring down and clarifying as he substitutes the needle for the brush, Munch achieves a high degree of concentration through the greatest economy of means.

Munch's achievement in the rendition of visions so weighted with literary and symbolic associations lies in his ability to follow an archetypal pattern closely enough to convey its transcendent validity, while at the same time modifying it sufficiently to avoid the inherent banality of the theme.

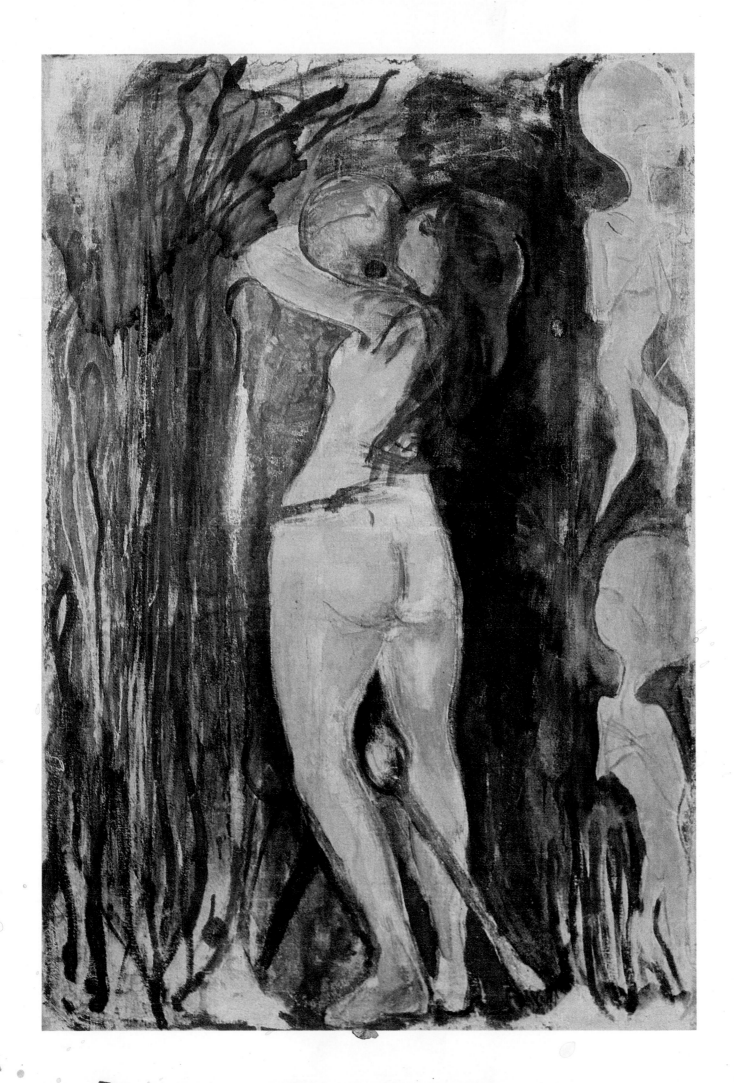

PUBERTY

Painted about 1893. Oil on canvas, 59⅝ × 43¼"
Nasjonalgalleriet, Oslo

Puberty is the most compelling in a series of oils that have as their subject a feminine being—woman or girl —seated on a bed. Chronologically, the string of these related compositions begins as early as 1884 with *Girl Sitting on a Bed* (fig. 78), to be continued in the first conception of the puberty theme a year or two later. The work reproduced here and other versions of the subject executed in the early and middle nineties are re-creations of a painting originally completed in 1885–86 which was destroyed by fire.

Puberty occasionally appears under the alternate title *At Night*. A nude adolescent girl stares tensely out of the canvas, holding overlong arms crossed in her lap so as to cover the object of her fear. A personification of teen-age terror, she reflects the disturbance caused by a novel and deeply upsetting experience. This common interpretation of the content of *Puberty* is not solely based on a reading of posture and physiognomy, but derives also from a mysteriously looming shadow (fig. 71). In an earlier version at the Munch-museet—one that through its texture suggests greater closeness to the lost original of 1885–86—the same shadow contour, even more angular and ominous, appears as a dark, flat shape almost suggestive of another person. Yet more insistent in this respect is an etching of 1902 (fig. 72), in which the protagonist has shifted from center to the right bedside whereas the shadow now seems to emanate from the pubic focus itself, alluding to the menstruation theme with unmistakable clarity. Although *Puberty* was read at the time of its creation chiefly in terms of social comment, we are aware today that in works like this Munch comes to grips with that borderline between the organic and the psychic that is at the core of Freudian thought.

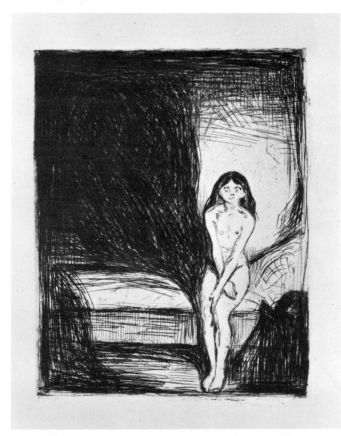

above left: Figure 71. THE YOUNG MODEL. 1894. Lithograph, 16⅛ × 10¾". (Sch.8)

above right: Figure 72. AT NIGHT (PUBERTY). 1902. Etching, 7¾ × 6¼". (Sch.64)

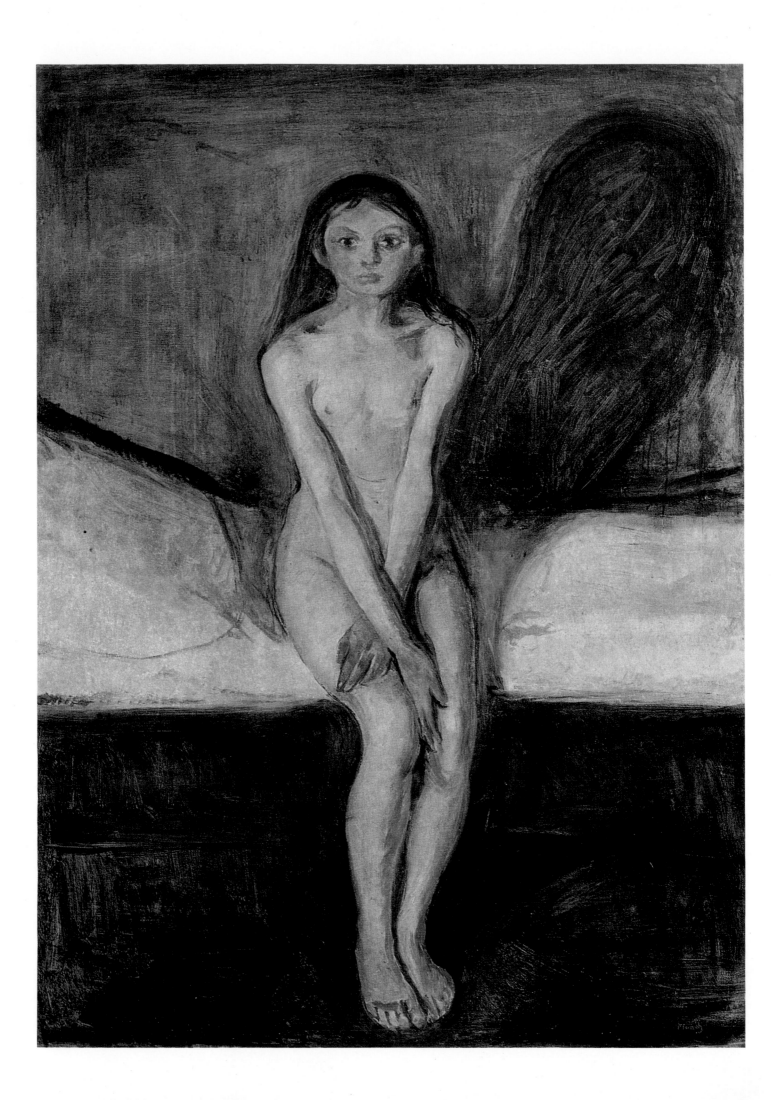

MOONLIGHT

Painted about 1893. Oil on canvas, 55¼×53⅛"
Nasjonalgalleriet, Oslo

By painting colors and lines that I had seen in an emotional mood, I wanted to make the emotional mood ring out again as happens on a gramophone.

Romantic overtones are inseparable from a solitary moon-drenched lady whose tense features seem to suggest some fateful encounter. The woman emerges like an apparition from the surrounding darkness. She stands straight and upright like a column against a white fence that borrows pale reflections from a reflected moon. A ghostly irreality pervades the entire scene. Every aspect of the painting emphasizes its strange symbolic qualities: the woman's greenish shadow, which usurps our attention through its bizarre shape and its insinuating color, cannot be reconciled

with the outline of her body, which melts with dark force lines that rush in from the upper canvas area. Adding to the enigma is a reddish half-averted figure that makes an unexplained exit from the lower left corner.

A color woodcut (fig. 73), Munch's first work in this relief medium, reverses the image and limits itself to a half-length rendition of the woman, thereby removing the fence that lends depth to the painting. The print surface, thus flattened, was created in 1896, three years after the painting was completed. Munch apparently wished to clarify some of the ambiguities of the earlier oil. He substituted tree forms for the abstract force lines of the painting, adjusted the shadow behind the woman to a reconcilable size and shape, and finally eliminated the mysterious, quasi-human half-figure.

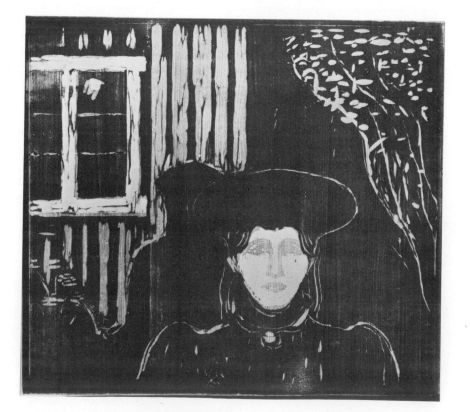

Figure 73. MOONLIGHT.
1896. Color woodcut,
15⅞×18⅝".
(Sch.81)

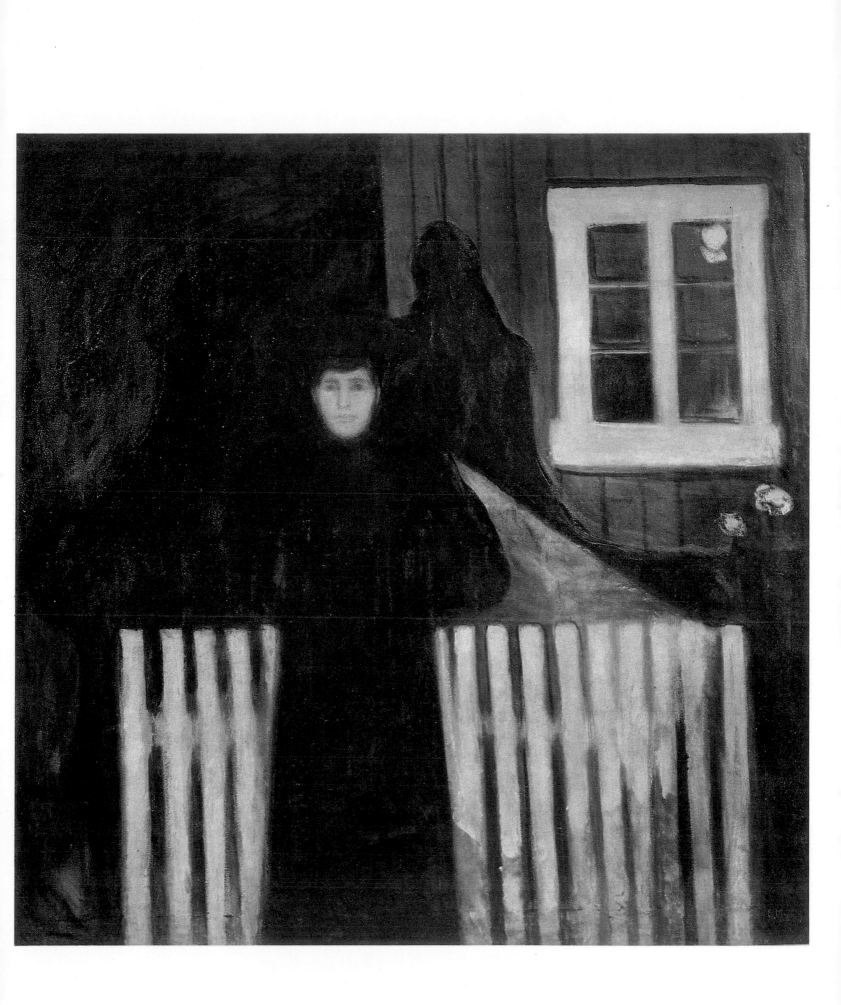

THE SCREAM

Painted 1893. Oil on canvas, 35¾ × 29″
Nasjonalgalleriet, Oslo

One evening I was walking along a path—on one side lay the city and below me the fjord. I was tired and ill—I stopped and looked out across the fjord—the sun was setting—the clouds were dyed red like blood.

I felt a scream pass through nature; it seemed to me that I could hear the scream. I painted this picture—painted the clouds as real blood.—The colors were screaming.—This became the picture The Scream *from the* Frieze of Life.

Nothing external gives a clue to the horror that impels the outcry. The terror-stricken subject—apparently a woman—looks past us while bending toward a railing that seems to extend endlessly behind her. Holding her ears, she hardly could hear the fading footsteps of two male figures receding into the distance. Nor could she, her back being turned, see two boats, or a distant church steeple that could redeem her complete isolation. Totally alienated from reality, the victim thus is overcome by the realization of an unspeakable terror from within.

Although Munch employed colors with some degree of naturalistic pertinence, the blue water, brown earth, green vegetation, and red sky are expressively heightened without leading to arbitrary abridgments of

coloristic plausibility. The hues are gloomy: a deep blood-red hovers ominously over the horizon and clashes with the violet shades of the sea, which darkens in the distance. The same violet repeats itself in the victim's dress, leaving her hands and head in gray-brown pallor.

The bandlike arrangements that lend intensity and swirling motion to the composition as a whole have often been identified as visualizations of sound waves. An alternate reading might relate them to such externalizations of force and energy as may be found in Van Gogh's famous *Starry Night* at the Museum of Modern Art in New York City. In any case, by lodging an extreme inner anxiety within the aural concept of the scream, and by rendering it visual through a convincing abstract imagery, Munch achieves a well-nigh unsurpassable emotional pitch.

In a lithograph of 1895 (fig. 74), in which he resumes an identical motif, the intensity of the psychological content is even further heightened. The protagonist's body contour is here dissolved and her identity remains establishable only in the negative, as the area corresponding to her presumed existence merges with that of the immediate environment. The graphic process here proves its full expressive capacities through an omission of descriptive detail and a powerful summarization.

Besides a near-identical oil version at the Munchmuseet, probably of the same year, and the already mentioned lithograph, attention should be drawn to the oil painting *Despair* of 1892 (fig. 75). In the earlier work, an averted male profile is projected against the already fully developed surroundings of *The Scream*. The subsequently executed *Anxiety* (colorplate 17) also falls back on the same scene, both in painted and in various printed versions.

Figure 74.
THE SCREAM. 1895.
Lithograph, 13¾×9⅞″.
(Sch.32)
Munch inscribed the print:
Geschrei/Ich fühlte das grosse Geschrei/ durch die Natur.
(I felt a great scream
pass through Nature.)

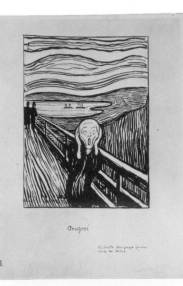

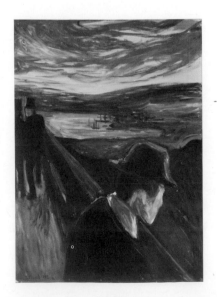

Figure 75. DESPAIR.
1892. Oil on canvas,
39⅜×31⅞″.
*Thielska Galleriet,
Stockholm*

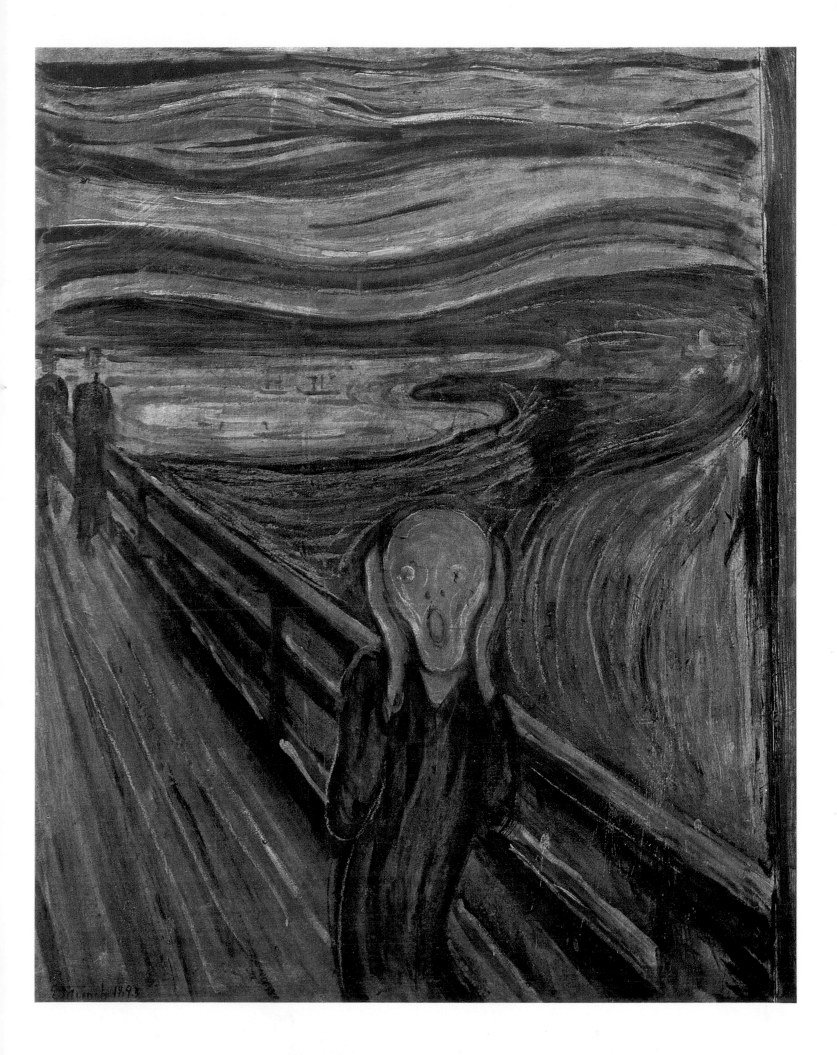

THE VOICE

Painted 1893. Oil on canvas, 34⅝ × 43¼″
Museum of Fine Arts, Boston

The pictures showing a beach and trees, in which the same colors keep recurring, receive their overall tone from the summer night.—

The Voice is a lyrical counterpart to the dramatic *The Scream* (colorplate 13) of the same year. It is one of Munch's most harmonious paintings and is free from the anguished mood that characterizes so much of his work of this period. A tense acuteness nevertheless emanates from the woman in white who stands erect and quiet like the trees that surround her, listening intently within herself. As in *The Scream*, the action is within: the voice is internal; the human being is a mute register; the visible world is a silent bystander.

Figure 76.
SUMMER NIGHT. 1895.
Drypoint and aquatint,
9½ × 12⅜″.
(Sch.19)

A little boat passes in the distance, but its passengers belong to the noisy world of make-believe and do not participate in the inner silence that alone is real. By the soft discord of its irrelevance the boat episode serves to enhance the principal theme of consonance.

Such consonance as resolution of tensions rather than as mere placidity may be traced in *The Voice* through precise formal counterparts. Munch relies on the verticality of nine tree trunks to provide a visual scale. They come down with full weight from beyond the upper picture limit to rest on a gentle slope rather than on a horizontal base, thereby creating a formal balance that is firm but not rigidly secured. A live, rhythmical relationship among the vertical stresses is achieved through a carefully determined uneven placement. Proportions function on the surface but also reach into the picture space to evoke a measured dimensionality that extends from the image itself onto the surrounding environment to create an enveloping mood.

Finally, the structural firmness of the work as well as the intensity of the pictorial content are effectively reinforced by one of Munch's favorite images—the sun or moon reflection in the sea. By calling on it in *The Voice*, and by using it with schematic clarity, the artist achieves a multiplicity of results. The diffused illumination in the foreground is rendered plausible through the presence of a visible light source. The structural scaffolding of the tree trunks gains a central member while at the same time the quasi-musical scale based upon nine accents is brought to full resolution through a resolving chord. The conceptual opposition and a simultaneously implied unity between water and fire as well as the erotic symbolism of the phallic shape invite a pantheistic interpretation—a love embrace of the elements—that raises Munch's *Frieze of Life* from transitory to transcendent significance.

In one of Munch's finest drypoints (fig. 76), completed in 1895, two years after the painting, the theme is further enhanced. The woman's features are ecstatic as she listens. The tree trunks, a touch less vertical now, have become more massive, enveloping the human protagonist even more closely. The number has been maintained at nine, but the scale determined by their relative position has gained in expressive urgency. The little boat, now seen in its full length, reveals a third rider who was hidden in the earlier canvas. The sun-moon shape has swelled to maximal proportion.

STARRY NIGHT

Painted about 1893. Oil on canvas, 53⅛ × 55⅛"
Collection Johan Henrik Andresen, Oslo

The Frieze is conceived as a series of decorative pictures which will collectively present a picture of life. They are traversed by the curved shoreline; beyond lies the ever-moving sea, and under the tree-tops is life in all its fullness, its variety, its joys and its sufferings.

Munch's setting for many of the *Frieze* paintings is the beach at Aasgaardstrand in the Oslo Fjord, where he had spent his summers since the late 1880s. He came to love the shore with its stony beaches that separated the sea from the forest, and it is this particular scenery that we come upon repeatedly in such works as *Starry Night*. One of its most prominent motifs is the hugely bulking shape of three linden trees whose crowns have merged to form a single outline. Prosaic enough in actuality, but raised by Munch's nocturnal vision to unexpected potency, the tree group with the white fence in front and even the white flagpole that stands out against the foliage like a mysterious light reflection may still be found in their places today, testifying to Munch's fundamentally literal approach.

Starry Night follows Van Gogh's work, of the same title but of very different conception, by about three years. It exists in two similar versions painted in oil on canvas, of which this is the earlier. Sky, water, and earth, divided yet rejoined in a larger unity, are the subject of this work. Land and sea are locked in an embrace in which each advances toward and recedes from the other. The dividing line marking the contiguous position of the two elements undulates boldly from the left foreground deep into the picture space before losing itself in the conspicuously inverted U-form fashioned by the combined tree crowns. Contained in

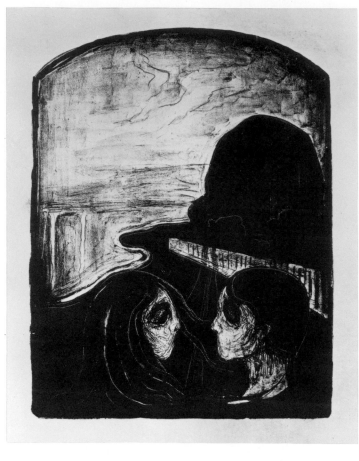

Figure 77. ATTRACTION. 1896. Lithograph, 18⅝ × 14⅜". (Sch.65)

this anthropomorphic vision of nature are the recurrent themes of human life and love rendered through an impersonal parable.

While tree shape and shoreline at Aasgaardstrand recur frequently, Munch saved the specific reiteration of the *Starry Night* theme for three print versions, two etchings of 1895 and a lithograph of 1896. The etchings titled *Lovers on the Beach* are printed in reverse from each other, one following and the other opposing the direction of the painting; the lithograph again conforms with the painted prototype (figs. 2, 3, 77). The prints render explicit the human content that the canvas held subsumed. As in *Moonlight* (colorplate 12), they clarify a subject matter that the oil painting merely hints at. Without such clarification the head-shaped shadow cast upon the white fence remains puzzling in the version here described and even more so in the *Starry Night* oil of 1902, where the same shape rises firmly from the central darkness of the picture surface.

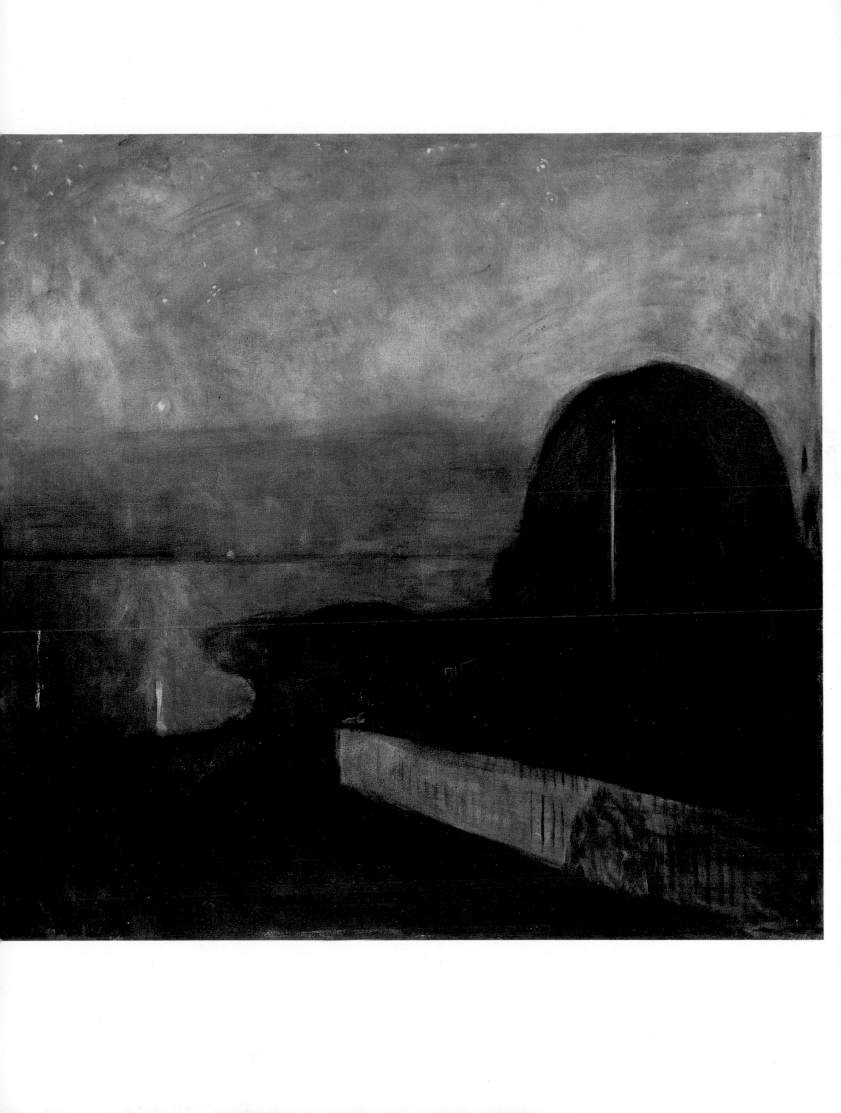

MADONNA

Painted 1893–94. Oil on canvas, 35½×27″
Munch-museet, Oslo

Nature is not only that which is visible to the eye—it also presents the inner pictures of the soul—the pictures on the reverse side of the eye.

This evocative painting has had several titles: first the more appropriate *Loving Woman*; Strindberg referred to it as *Conception*. The current name may be justified by the pervasive purity of the feminine features and by Munch's religious attitude toward love. The vision that he conjures up in *Madonna* is a passionate portrayal of yielding womanhood grasped in its carnal and spiritual unity. Flowing black hair, covered with a halo-shaped scarlet band, undulates concentrically around the woman's nude torso. Her ecstatic features are lifted upward and her eyes are closed in a gesture of abandon. Defenselessness is stressed by the position of the arms: one appears to be fastened behind, while the other is bent upward as if held in an invisible grip. The force lines are conceived as extensions of hair and suggest swirling motion within a symbolic color range that envelops the woman like an aura—that colored emanation of the psyche which, according to theosophic notions, invisibly surrounds every living creature.

As is usual with Munch, elaboration in the print mediums follows the painted prototype, which itself exists in a number of versions—notably, two in Oslo and one in Hamburg—among which the painting here discussed is the earliest. The most famous of the prints directly relating to *Madonna* are a drypoint of 1895 and a color lithograph series beginning in the same year (figs. 78, 79).

above: Figure 78. MADONNA. 1895.
Drypoint, 14⅛ × 10½″. (Sch.16/II)

right: Figure 79. MADONNA. 1895–1902.
Color lithograph, 23⅞ × 17½″. (Sch.33/A/II/b)

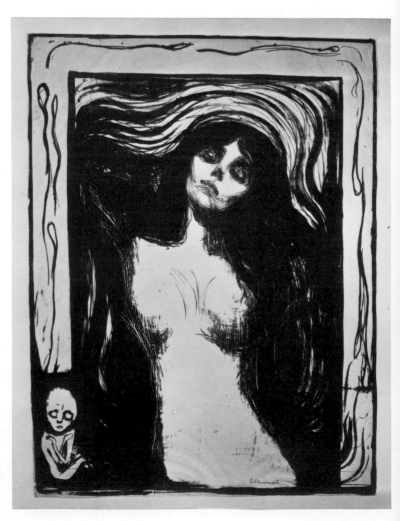

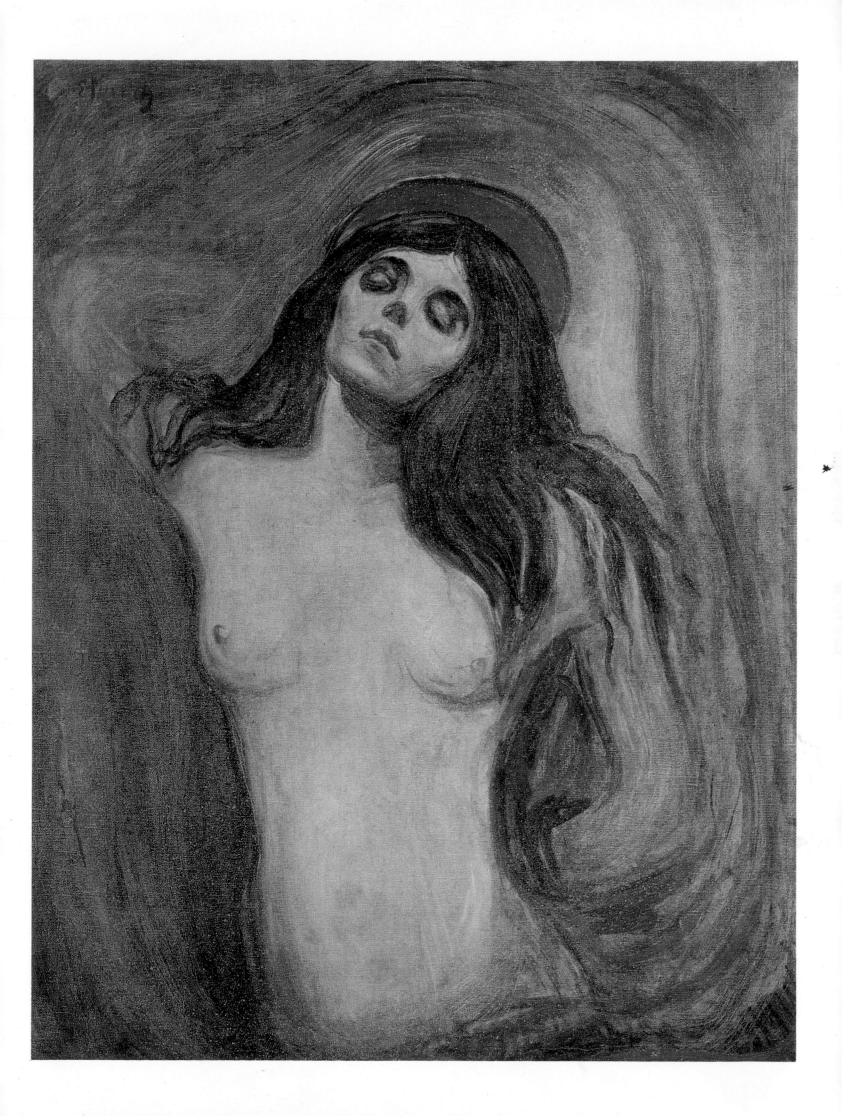

ANADISETY

Painted 1894. Oil on canvas, $36\frac{5}{8} \times 28\frac{3}{8}''$
Munch-museet, Oslo

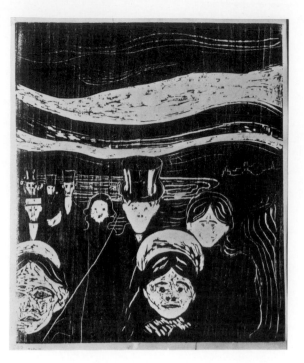

Figure 81. ANXIETY. 1896. Color woodcut, $18\frac{1}{8} \times 14\frac{7}{8}''$. (Sch.62)

The Frieze *is intended to be a poem on life, love, and death.*

This painting draws on two earlier departures: the anxious humanity moving forward as if driven by ominous elemental forces, as first conceived in *Evening on Karl Johan Street* (colorplate 9); and a certain view of Oslo Fjord, already seen in *The Scream* (colorplate 13). Both were destined to recur with considerable fidelity in *Anxiety* and in other works of the same period.

Norwegian angst, like its German counterpart, had become the key term not only for Munch's central pictorial content but for the entire tradition that is traced to Kierkegaard's and Nietzsche's philosophies, Strindberg's and Ibsen's plays, and the North European modern aesthetic contribution in general.

In *Anxiety* Munch repeats closely many elements of *The Scream*. The same jetty that accommodated a

single alienated personage appears again, as do the lake in the distance, the two boats, the church, and other structures that line the shore just a little less dimly than before. They are all quoted from the earlier work, as are the gloomy hues and the intense swirls of concentrically enlarging lines that define and ultimately embrace land, sea, and sky.

If, however, *The Scream* deals with the horror experienced in total isolation by a single being, *Anxiety* plays upon collective despair. The sentiment of angst in this work is even more sustained, if less piercing, than in *The Scream*, since its desperation is here borne by a group rather than by an isolated individual.

Munch returned to *Anxiety* two years later to restate the same motif through the print mediums. This time he added the woodcut to the lithograph and allowed the white features rendered visible in the subtractive method to stand against the expressive ground of a red-colored paper (figs. 80, 81). As has been observed in *The Scream*, the limitations inherent in the graphic technique—its reduction of the linear property and the elimination of the descriptive color in the woodcut—emphasize the abstract conception and heighten the emotive forcefulness of the pictorial content. The few but significant modifications and character substitutions that the artist felt compelled to undertake in the transformations from painting to prints, as well as the subtle differences between woodcuts and lithographs, provide valuable insights into Munch's creative reactions.

Figure 80. ANXIETY. 1896. Color lithograph, $16\frac{1}{2} \times 15\frac{1}{4}''$. (Sch.61)

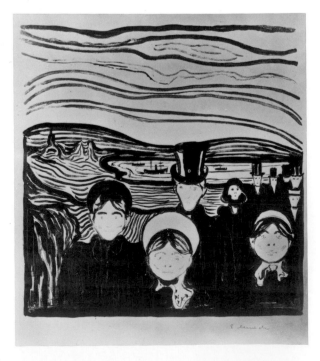

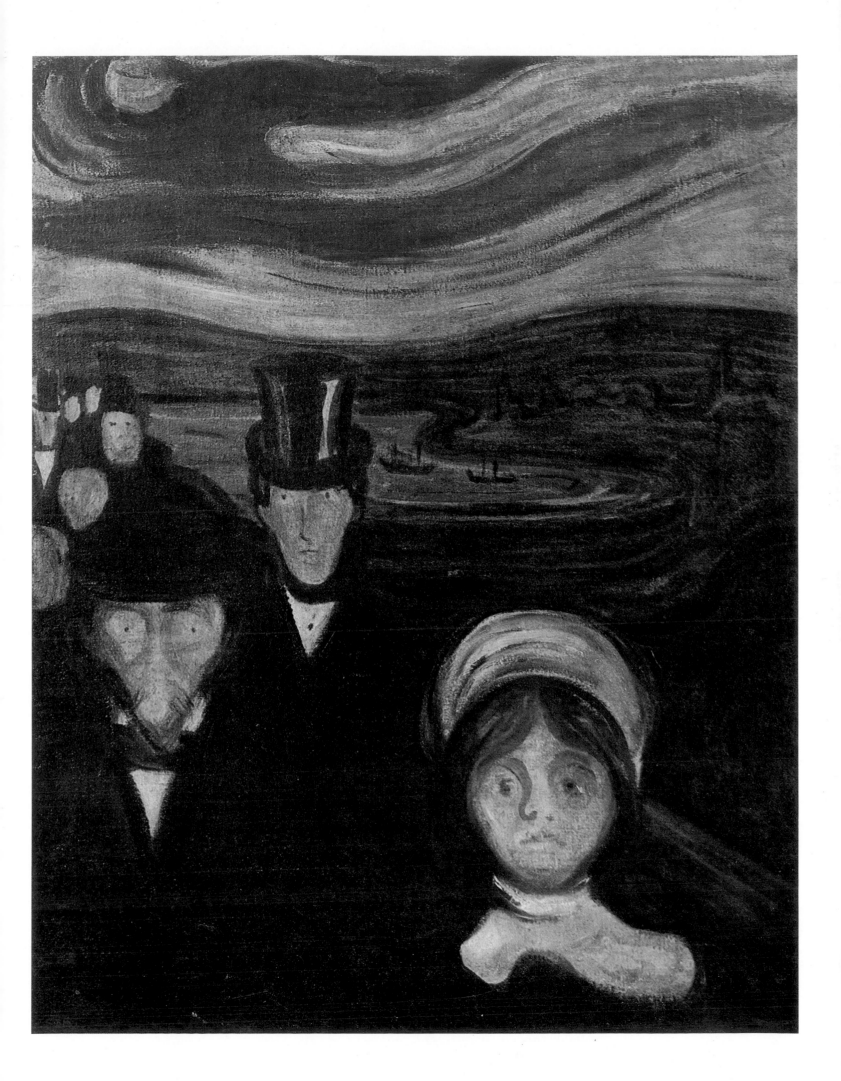

JEALOUSY

Painted about 1895. Oil on canvas, 26¼ × 39½"
Rasmus Meyers Samlinger, Bergen

Jealousy—the Pole with a bullet in his head.—

This most famous of the *Jealousy* canvases brings together the Adam and Eve theme with the portrayal of Stanislaw Przybyszewski. Munch's Polish poet friend, with his prominent bearded features, is also rendered in an oil painting of 1893–94 (fig. 88).

Przybyszewski's likeness in *Jealousy* has often been linked to Munch's presumably amorous relationship with the poet's wife, Dagny Juell, whom he painted in 1893—the year of her marriage (fig. 12). The charged triangular situation, which in various degrees of recognizability reveals the features of the same protagonists, is also reflected in an oil of 1913 at the Munchmuseet and in other related versions, among them *Passion* (fig. 82). Thus passion, jealousy, the biblical allegory of temptation, and an autobiographical incident converge in Munch's work, recurring in paintings and prints at different times.

The small Bergen oil is firmly structured and the definition of the picture planes is exceptionally clear. Przybyszewski occupies the extreme foreground, tree and door share the middle plane, and the quasi-biblical occurrence recedes into the distant picture space.

Munch here preserves the anonymity of the situation by lending recognizable features to Przybyszewski only. Eve, partly covered by a scarlet garment, exposes a naked front—much in the way of the central figure in the various versions of *Woman in Three Stages* (colorplate 20). She is pictured as she picks the fateful apple—an act translatable to the jealous mind of the brooding foreground figure as apprehension in flagrante delicto. Przybyszewski's colorless features are in effective contrast with the sensuous redness of Eve's face and flowing garment—a redness that in turn is echoed by the sinful apple and the potted plant posted before the door of Eden. Adam appears in modern dress. The deviation from biblical nudity serves, of course, to restate the old theme in a contemporary context. Whether intended or not, the clad and veiled bodies of the original sinners also suggest that their innocence had been impaired even before the modern reenactment of the fateful deed. A sinuous pattern envelops the work within a formal unity that comprises thinker and thought, dream and reality, linking *Jealousy* to the style of the 1890s known by such names as Art Nouveau and Jugendstil.

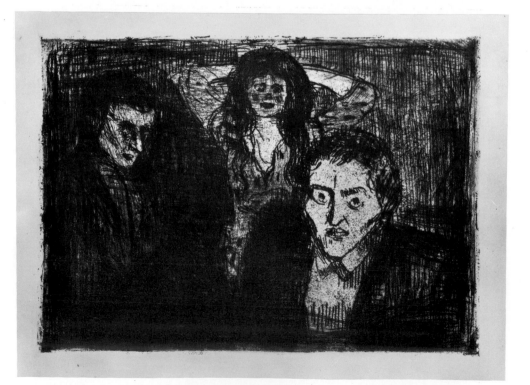

Figure 82. PASSION (JEALOUSY). 1913–14. Etching and drypoint, 7⅝ × 10⅝". (Sch.395)

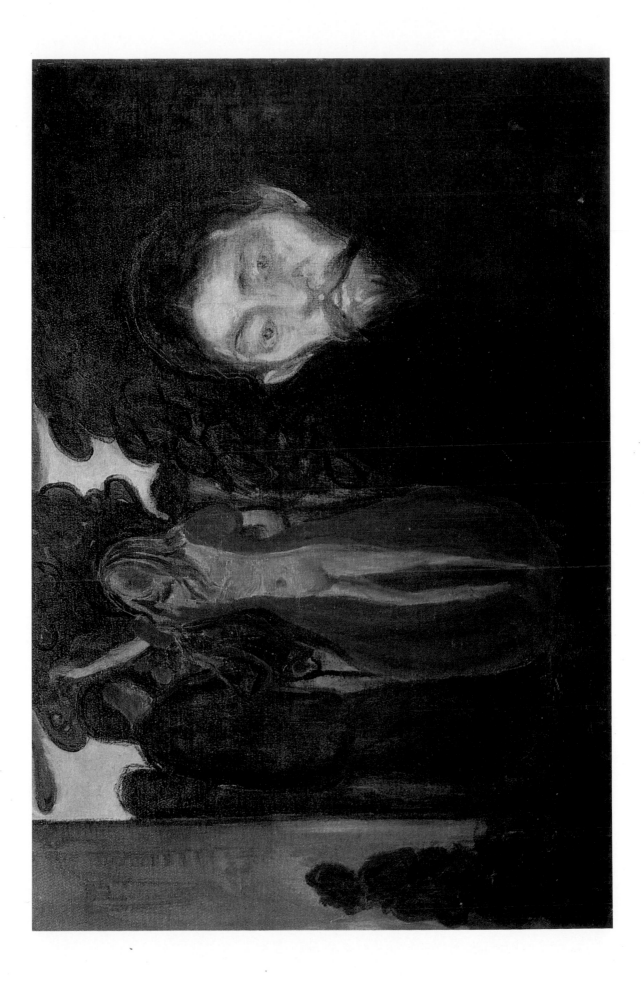

SELF-PORTRAIT

Painted 1895. *Oil on canvas*, 43½ × 33⅝"
Nasjonalgalleriet, Oslo

This three-quarter view of the artist reveals him in elegant, worldly attire but in a tense, pensive, and introspective mood that draws the viewer's attention away from the outward posture to the inner likeness. Munch shows himself at thirty-two somewhere between the earlier *Self-Portrait Beneath the Mask* (frontispiece) and the subsequent *Self-Portrait with Wine Bottle* (colorplate 29), no longer boyish nor as yet middle-aged, but in youthful maturity that combines poise and self-assurance with nervous tension and traces of bitterness.

This *Self-Portrait*, a study in pictorial ambiguity, must be considered a model and point of departure for subsequent Expressionist portrait conceptions. Figure and environment are conceived in an inseparable unity. As one penetrates the other and is, in turn, engulfed by its opposite, existence itself is simultaneously affirmed and negated. Blurring of contour and background takes place within a shallow picture space in which color moves along a narrow range and a central blue nods alternately toward brown and green. The main features—face and hand—set off by the whiteness of the collar and the light border of a cuff, emerge in luminous relief against an amorphous picture plane.

The free, gestural application of paint in this canvas cannot fail to suggest to contemporary sensibilities a certain relevance to much later modes of Expressionism. Working with a spontaneity and a deliberate disregard for surface finesse, Munch allows the free flow of paint to create incidental surface effects through overlapping application and through sheer dripping. By demonstrating without further insistence the independent life of the material component, the Norwegian master in his late-nineteenth-century phase showed himself possessed of an insight that was to engage another generation of painters a half-century later.

Self-Portrait, a lithograph (fig. 83) of the same year, transforms the brooding introspection of the canvas likeness into a moribund death vision. The print projects Munch's somber features in dramatic whiteness against a surrounding black void. The slight tilt of the face in the oil now gives way to an unmitigated frontality to bring both ears into full and somewhat abrupt prominence. The whiteness then returns on two margins: the upper, to state in large printed letters the identity of the sitter and the date of completion; the lower, to accommodate the skeletal forearm and the fleshless bones of the hand, which figures with opulent prominence in the oil painting of the same year. The much later lithograph, *Self-Portrait with a Cigarette* of 1908–9 (fig. 84), retains clear similarities to the oil painting but changes the position of head and hand to lend Munch's now clean-shaven features an air of comfort and ease lacking in the earlier work.

left: Figure 83.
SELF-PORTRAIT. 1895.
Lithograph, 18¼ × 12¾".
(Sch.31)

right: Figure 84.
SELF-PORTRAIT WITH
A CIGARETTE. 1908–9.
Lithograph, 22 × 18".
(Sch.282)

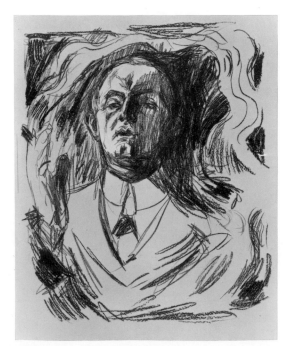

WOMAN IN THREE STAGES

Painted 1895. Oil on canvas, 64⅝×98⅜″
Rasmus Meyers Samlinger, Bergen

above: Figure 85. PARTING
(WITHDRAWAL, LIBERATION II).
1896. Lithograph, 18×22½″.
(Sch.67)

It was in 1895.—I had an exhibition in the autumn at Blom-qvist's.—The pictures caused a tremendous uproar.—People wanted to boycott the gallery—call the police.—

One day I met Ibsen there. . . . He showed particular interest in Woman in Three Stages. *I had to explain the picture to him. Here is the dreaming woman—there the woman hungry for life—and the woman as a nun—standing palefaced behind the trees. . . . A few years later Ibsen wrote* When We Dead Awaken. *. . . These three female figures appear in many places in Ibsen's drama—as in my picture.*

This large canvas, sometimes called *Sphinx*, is the principal version of a theme that Munch frequently repeated and modified. It is the recognizable point of origin for *The Dance of Life* (colorplate 24), and it derives in turn from numerous works depicting the confrontation of Man and Woman. It is also closely related to the simpler parting or detachment theme, recorded in a number of oils and prints, from which it has borrowed two principal personages—the maiden and her lover (figs. 4, 5, 85)

In *Woman in Three Stages* the chronology of womanhood becomes the main symbolic content. To preserve its continuity the male figure is shifted to the right picture margin and is isolated between two tree trunks. The red plant is the same as in the probably earlier *Jealousy* (colorplate 18), but assumes the added significance of shedding life blood—a motif fully developed in *Parting*. It is characteristic for Munch to seek plausibility even in his most fanciful themes, but such insistence upon credibility does not reduce the power of Munch's symbols. The virgin is white, in a billowing dress with flowing hair, standing on the sand strip between water and forest and straining toward a distant horizon. As in *The Dance of Life*, the central position is occupied by Woman in full and sensuous maturity. Here she is rendered naked, provocatively frontal, red-haired and red-lipped, with her arms raised and her head tilted in brazen coquetry and whorish contrast with her other selves. Close to her, like a shadow, is a dark image of spent womanhood whose embodiment stands with raised shoulders, slim waist, and pointed mouth, somewhat like Inger Munch in the portrait of 1892 (colorplate 7). This last of the three women is nearest to Man, both in position and in the somber black clothing.

Central to the sequence of the *Frieze of Life*, *Woman in Three Stages* reiterates the scene at Aasgaardstrand with its powerfully swirling beach line as the unifying formal element.

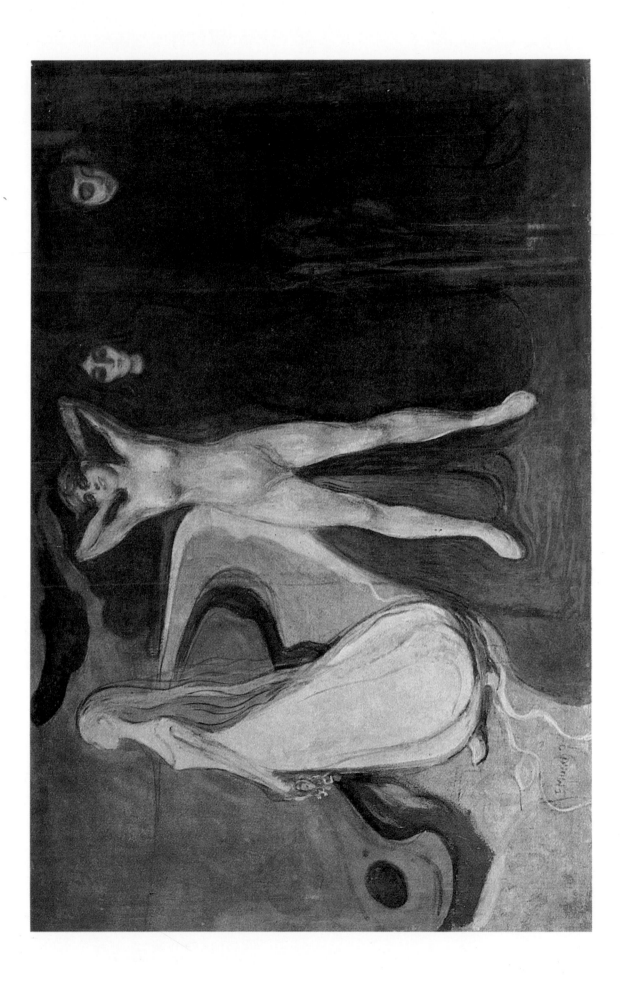

COLORPLATE 21

MOTHER AND DAUGHTER

Painted 1897. Oil on canvas, 53⅛×64⅛″
Nasjonalgalleriet, Oslo

Figure 86. POSTER FOR "PEER GYNT." 1896.
Lithograph, 9⅞×11½″. (Sch.74/B)

*The lascivious white body against the black colors of mourning
in the mystic light of the bright summer night.*

In the recurring theme of Woman, *Mother and Daughter* may be read as a variation of the pivotal *Woman in Three Stages* (colorplate 20). The earlier painting presents Woman as she relates to Man, and this canvas introduces two "stages" of Woman in complicated relationship to each other.

Munch's preoccupation with the psyche of modern man leads him beyond the solitary figure to various groupings, and from the investigation of states of mind characterizing individuals to those indicative of human relationships. The recurrent images of lovers, the Jealousy theme, the phases of Woman in various constellations, and *Mother and Daughter* are among such double and group portrayals. Here age is separated

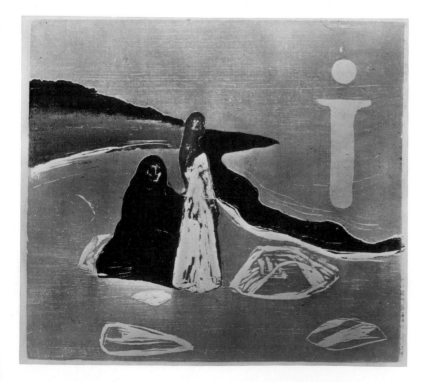

from youth through an extreme tonal contrast, but common ground between the two generations is maintained through intermediary violet-blues, which in one instance lighten and in the other darken the basic tonality. The rising diagonal of a jagged horizon line and the plantlike formations that reach ominously like grasping hands toward the protagonists of an archetypal conflict inject a sense of tension that underlies the hieratic relationship of matriarchal domination and filial suppression. The posture of the younger woman in its frontal rigidity recalls the earlier portrait of *Inger Munch* (colorplate 7), while the seated older woman in half-profile brings to mind with equal explicitness the corresponding figure in *Spring* (colorplate 3) —the artist's aunt and foster mother, Karen Bjølstad.

The averted postures of an old and young woman occur first in a program poster designed by Munch for a French production of Ibsen's *Peer Gynt* in 1896 (fig. 86). It would seem likely that the relationship between Aase and Solveig led him subsequently to a reiteration of the same motif in more general terms. A number of prints exploring the same theme are indicative of Munch's sustained interest in the subject. The first among these, a woodcut (fig. 87), follows the painting within a year, whereas the last relevant version is an oil at the Munch-museet dated as late as 1938. In most of these related works the mother-and-daughter confrontation has settled into an identical formulation showing the seated older woman turned inward toward land and the standing girl facing the sea.

Figure 87. WOMAN ON THE BEACH. 1898.
Color woodcut, 17⅞×20¼″. (Sch.117)

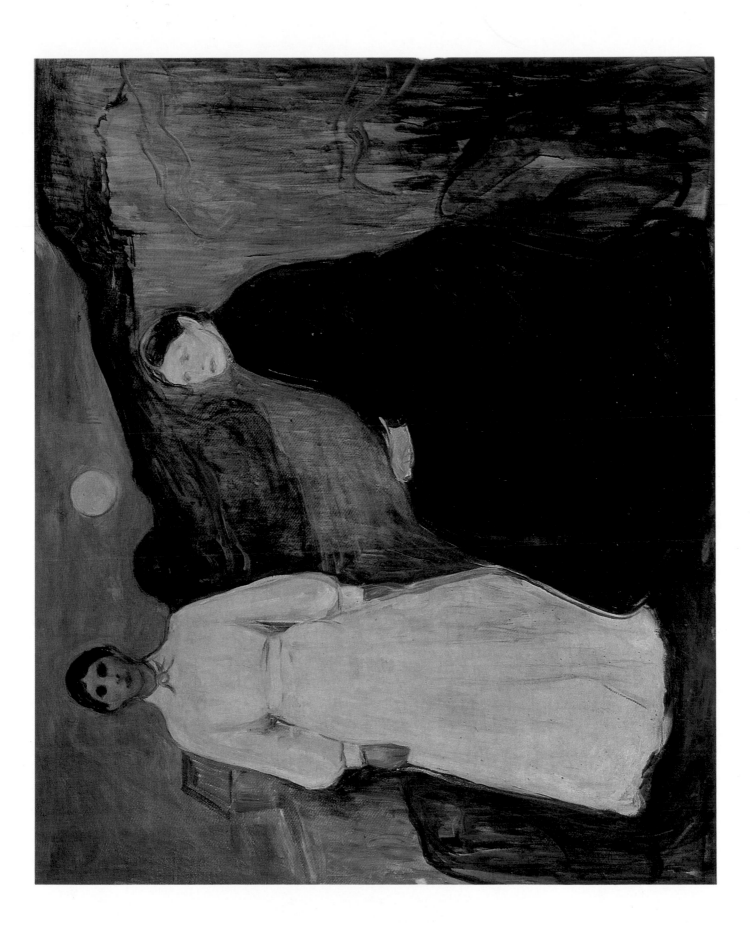

COLORPLATE 22

THE RED VINE

Painted 1898. Oil on canvas, 47 × 47⅝″
Munch-museet, Oslo

I do not paint from Nature—I take my subjects from her—or draw from her plenitude. Art is the antithesis of nature.

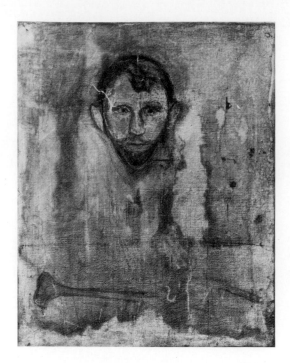

Figure 88.
STANISLAW
PRZYBYSZEWSKI.
c.1893–94.
Oil on canvas,
29½ × 23½″.
Munch-museet, Oslo

Man and his environment have a part in the silent drama enacted in *The Red Vine*. The houses, anthropomorphically conceived, appear as animated beings frozen into lifelessness by an evil spell. One house looks upon the world through cool blue window-eyes, the other is engulfed by flaming reds that are reluctantly admitted as vines but are more profoundly read as fire or blood. The human incarnation seems to sink into the earth as it conveys a tragic awareness through dark-red eyes set deeply within a green-gray face. A transparent Northern light envelops the unspecified calamity.

Munch, in such major works as *The Red Vine*, approaches his work with a ready store of previously tested ideas and with tried pictorial devices. The sinking of a cut-off figure into a prominently advanced position first appears in *Military Band on Karl Johan Street, Oslo* (colorplate 4) and in *Jealousy* (colorplate 18). In both paintings there is an implication of severed

male heads, a motif tied to the Salome legend and a recurring feature in Munch's repertoire (figs. 89, 90). The device of the cut-off figure was taken from the Impressionists and is an example of the way in which Munch transformed the lessons of Paris for his own artistic purposes. The prominent frontal and spatial deployment of the heads in Munch's work adds emotional and psychological dimensions to what had previously been a formal solution. The features of the foreground figure, through its resemblance to Stanislaw Przybyszewski (fig. 88), strengthen further the common roots that underlie *The Red Vine* and *Jealousy*. The landscape also is thoroughly familiar as the prime locale of Munch's imagery during the years between 1889 and 1905, when he habitually visited Aasgaardstrand. Despite such an extensive dependence on available imagery Munch succeeds in creating a new work that, through an emotional content of its own, remains undulled by references to previous creations.

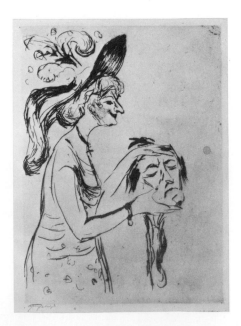

far left: Figure 89. SALOME
(SELF-PORTRAIT WITH EVA MUDOCCI).
1903. Lithograph, 16 × 12″.
(Sch. 213)

left: Figure 90. SALOME II.
1905. Drypoint, 5½ × 3⅞″.
(Sch. 223)

COLORPLATE 23

GIRLS ON THE JETTY

Painted about 1899. Oil on canvas, 53½ × 49⅜″
Nasjonalgalleriet, Oslo

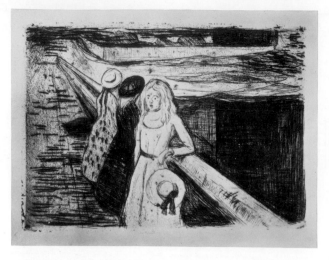

Figure 91. GIRLS ON A JETTY. 1903.
Etching and aquatint, 7⅛ × 9⅞″. (Sch. 200/III)

I do not paint what I see, but what I saw.

Perhaps more than any of Munch's paintings, *Girls on the Jetty* has gained a wide measure of justly deserved popularity. The theme engaged and held Munch's interest through many versions in paint and print, from the waning years of the nineteenth century to his old age.

Despite its poetic strain, *Girls on the Jetty* is a literal translation of a scene at Aasgaardstrand. Now, some seventy years after its original conception, the visitor to this spot at Oslo Fjord will find essentially unchanged the elongated pier continued by an upward sloping road, the curvature of the sandy shoreline interspersed with patches of green, and the old house itself surrounded in summer by foliage and overshadowed by the often portrayed three linden trees that have grown together as if to share a common crown. Framed by a white wooden fence, all these features are literal truth, not poetic fancy. In reflecting them, Munch turned his back on a picturesque little harbor on the invisible side of the jetty, fully furnished with small craft and all the banal trappings of a motif hunter's delight. Having

selected his subject with care, he adhered to it closely. Without inhibiting the transmutation from model to formal analogy, the chosen scene, on the contrary, led the artist to the perfect solution.

Munch never demonstrated more convincingly his ability to achieve simultaneous separateness and wholeness. The tree forms, while singly readable, create an articulated strain of natural growth with the patches of grass that, together, stand in a contrapuntal relationship to the man-made elements—the house, the fence, and the jetty. The polyphonic opposition between these parts and its final resolution in a consonant pictorial surface is achieved with extraordinary formal command.

The subtle dialogue between the landscape and its slightly altered reflection in the water allows us to taste the orderly pleasures of symmetry without incurring the accompanying liability of pedantic rigidity. The reflection restates the landscape motif with increased vibrato and in minor key. Bluish rooftops turn brown in their aqueous counterimage while the gray-white house facade assumes darkening admixtures. The tree group itself, green in the light of the summer night, is toned down to a brownish hue as it lengthens in a ghostlike manner. The yellow sun-moon is subtracted from the mirror image. Did Munch, still true to literal vision, omit it because the water ripples have blurred its faint light beyond recognition, or did his often demonstrated tact eliminate a possible flaw in a carefully balanced emotional equation?

In his usual way with a favorite subject, Munch made several versions of the oil and translated the scene into various print mediums. Among them are an etching and aquatint of 1903, and the much later mixed-medium print of 1918–20, which combines a color woodcut and a three-color lithograph (figs. 91, 92).

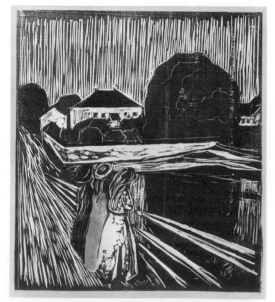

92

Figure 92. THREE GIRLS ON A JETTY. 1918–20.
Color woodcut and lithograph, 19⅝ × 16¾″. (Sch.488/b)

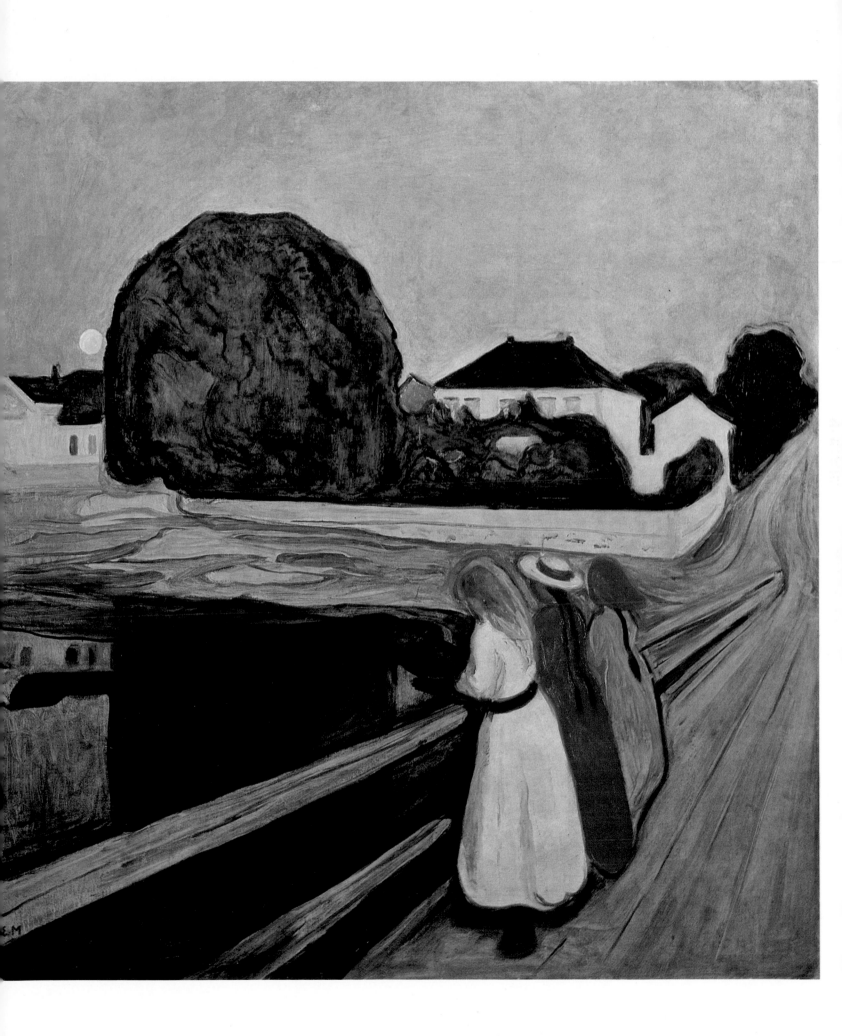

THE DANCE OF LIFE

Painted 1899–1900. Oil on canvas, 49½×75″
Nasjonalgalleriet, Oslo

The bright summer night, in which life and death, day and night, go hand in hand.

The Dance of Life may be seen as the centerpiece in the great thematic cycle that comprises the human condition and that Munch referred to as the *Frieze of Life*. Freely adjoining one another and without an explicit narrative order, these canvases and the related print sequences may be said to converge on the fateful love embrace of the central couple in this work, to move simultaneously toward youth and innocence, age and dejection, and beyond the *Dance* toward birth and death, lust and fertility, and toward melancholy, jealousy, and such inner portrayals as Munch had completed by the turn of the century. The *Frieze of Life* thus becomes an anthology of the psychic state of modern man.

On a meadow along the shore at Aasgaardstrand, the three stages of Woman dominate a frenetic scene of passionate dancing couples. A virginal girl dressed in white, smiling and pink cheeked, reaches out to a blossoming flower. In symbolic contrast is an older woman, hands folded, withdrawn, expression bitter, and somberly attired. Both are turned toward the center, which is occupied by a dancing pair—a man in a dark suit and a seductive woman in a scarlet dress, whose hair and skirt reach out to engulf her partner. The two are sunk within each other and move oblivious of others, without will or purpose. A distant sun or moon penetrates the waters with its ample reflection.

In this tripartite conception of Woman, explicit meanings are reinforced through symbolic imagery and color. Subject matter, formal structure, and symbolic content bespeak in unison the passage from innocent girlhood, to rapturous oblivion in the presence of Man, to the disillusionments of age.

The Dance of Life is the largest among the *Frieze* works of the 1890s, and one that was not re-created in major related versions. No prints of the *Dance* as such exist, and only one drawing of the same period in the Munch-museet testifies to the artist's further preoccupation with the subject (fig. 93). Yet the work is rooted in others which initially defined its constituent elements. Thus the beach at Aasgaardstrand with the totemic sun-moon motif appears as early as 1892 in such oils as the *Mystic Shore* (fig. 94). *Woman in Three Stages* (colorplate 20), which carries out to the full the symbolic separations reiterated in the *Dance*, appears first in a painting of 1894, to recur in numerous prints, many of which predate the grand version here under discussion. Finally, the physiognomies of the central couple and their movement within a field of emotional magnetism had been successfully exploited in the lithograph titled *Attachment* (fig. 1) and in its reverse image, *Parting* (fig. 4). *The Dance of Life* therefore may be seen as a grand recapitulation testifying to the fullness of Munch's capacity and achievement as a painter.

The paroxysms of Munch, like those of the Symbolists, took him beyond the limits of rationality, giving to this and other works a hallucinatory quality. Coming out of his inner life and the revelation of his deepest personal emotions, his finest work transcends the particular in its quest for the universal.

left: Figure 93.
STUDY FOR THE
DANCE OF LIFE.
1899. Ink and crayon
12¾×18¾″.
Munch-museet, Oslo

right: Figure 94.
MYSTIC SHORE.
c.1892. Oil on canvas,
39⅜×55⅛″.
*Gunnar Johnson Höst,
Gothenberg*

FERTILITY

Painted about 1902. *Oil on canvas,* 48 × 56¾″
Private collection, Oslo

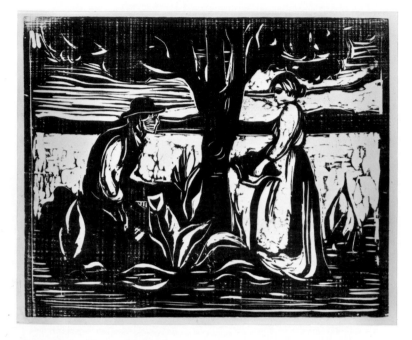

Figure 95. FERTILITY. 1898.
Woodcut, 16⅝ × 20¼″. (Sch.110)

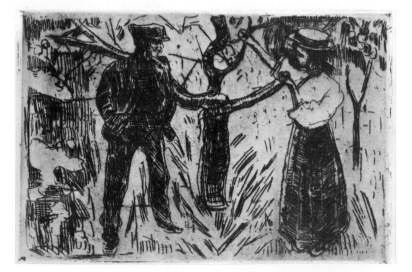

Figure 96. ADAM AND EVE. 1915.
Etching, 10¼ × 14½″. (Sch.430)

I have sold my picture—a tree with a man and a woman underneath—to a multimillionaire in Lübeck and have received 1000 *kr. for it.*

—letter to his aunt Karen Bjølstad,
August 3, 1902

Fertility is a work of unexpected calm, cast in a pastoral mood. The trunk of a prolific fruit tree provides a strong vertical, which in relation to the pronounced horizon line creates an axial structure. Green—always a symbol of serenity with the Norwegian master—is the dominant color.

The confrontation between Man and Woman in this canvas is free from episodic connotations and gravely meaningful. Adorned in festively rustic attire, gathered ceremoniously under the "tree of life," they consummate the offer of fruit and its acceptance through earnest and measured gestures. Not since Millet has peasantry been endowed with comparable attributes of quiet dignity.

The theme, under the same title, reappears in a closely related 1898 woodcut with reversed image (fig. 95). The etching *Adam and Eve* of 1915 (fig. 96), based in turn on a painting of 1908 at the Munchmuseet, retains the postures prefigured in *Fertility* but fails to convey a comparable sentiment. Through Eve's coquettish gesture and a reduction of the mythical scope to a confined narrative these later versions lose the quiet force of *Fertility*.

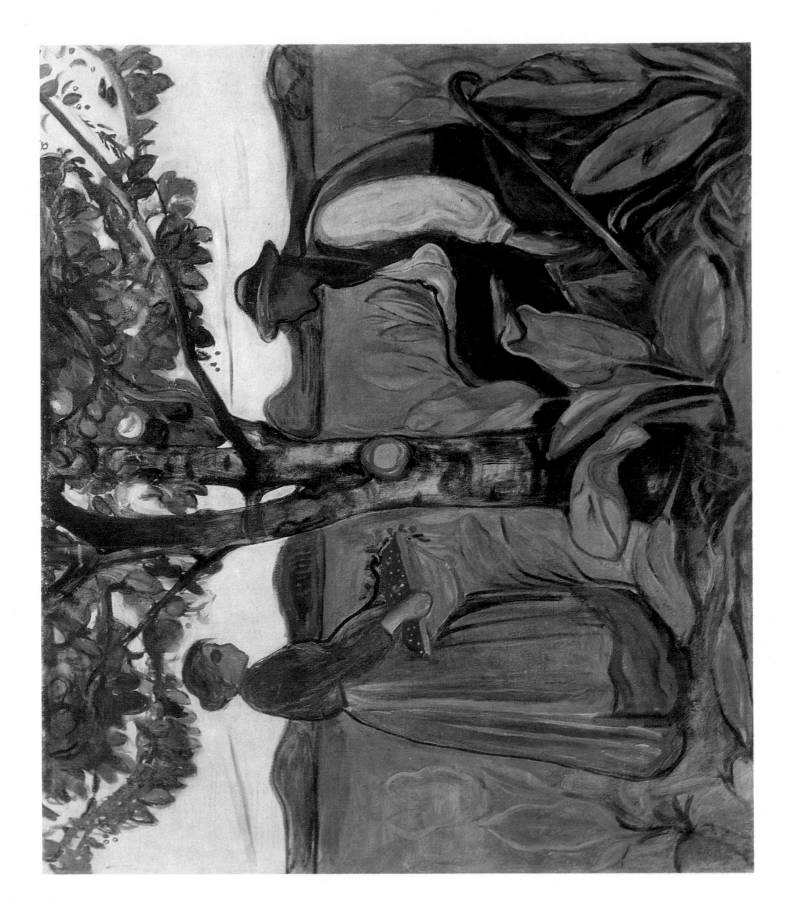

FOUR SONS OF MAX LINDE

Painted 1903. *Oil on canvas,* 56¾×78½″
Collection Das Behnhaus, Lübeck

Max Linde (fig. 97), who commissioned this portrait of his sons, was one of Munch's first important patrons, and the artist found frequent occasion to avail himself of the wealthy oculist's hospitality in Lübeck.

Throughout this extraordinary group portrait, Munch's spontaneous brush streaks downward on the white walls of the interior, crosshatches brown shadows on the shiny floor, and drips lightly here and there, giving a sense of ease and relaxed mastery to the work as a whole. Linde's sons stand about in front of a paneled doorway, which is treated as ornamental background.

Free patterns are formed upon it through light reflections conveyed in pastel colors and heightened with white. Only the simplest architectural structures—floor, walls, and door—surround the group, which thus holds the viewer's undivided attention, except perhaps for a shiny doorknob, fashioned with loving care, which serves as an indicator of the height and age levels of the children.

Munch frequently portrayed children. He successfully avoided the sentimentality and banality that often characterize such efforts. But it is difficult to imagine how he succeeded in making this quartet pose. In an age range that is characteristically unruly or at best inattentive, the necessary cooperation of the four youngsters must have been difficult to achieve, and the haphazard placement of the models does indeed suggest that much moving back and forth may have preceded the eventual freezing of positions. The brothers have in common their curly blond hair and eyes whose color remains somewhat ambiguous. It is rewarding to study their features in relation to those of their parents by examining the etchings in the *Linde Portfolio* (figs. 17, 97, 98).

Figure 97. PORTRAIT OF DR. MAX LINDE, FROM THE "LINDE PORTFOLIO." 1902. Drypoint, 12⅞×9″. (Sch.178)

Figure 98. PORTRAIT OF FRAU DR. LINDE, FROM THE "LINDE PORTFOLIO." 1902. Drypoint, 13¼×9⅝″. (Sch.177)

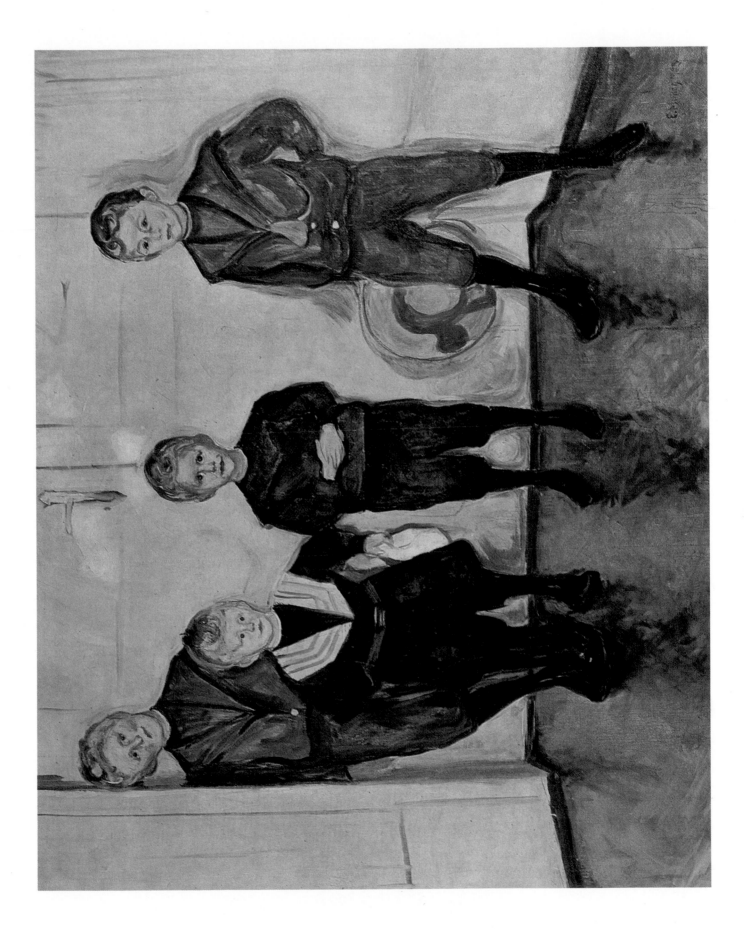

DANCE ON THE SHORE

Painted about 1904. *Oil on canvas,* 39 × 37¾"
Národní Galerie, Prague

This series [Frieze of Life] *I consider one of my most important works, if not the most important.*

This sparkling little canvas is related in subject matter and symbolic content to the monumental *Dance of Life* (colorplate 24), but it strikes an altogether different note despite the obvious parallels. The familiar shore scene is inhabited by five discernible figures who pursue their small pleasures under the rich evening glow of a setting sun. Two dancing girls in light dresses, two standing women in black, and a reclining figure in scarlet again seem to symbolize Woman in her three phases—youth, age, and maturity. In the left foreground a shape that could be an animal carcass would seem to provide a memento mori to contrast with the arcadian rites along the sea.

Despite these symbolic references, *Dance on the Shore* lacks allegorical explicitness and offers itself as light-hearted enchantment. A comparison with *The Dance of Life* brings into contrast the open meadow in the earlier painting with the sandy shoreline protected by a gently swaying tree branch of the work here illustrated. Only women inhabit the scene in *Dance on the Shore*, and their bearing is free from the fateful gravity that pervades *The Dance of Life* and the *Frieze* in general. While the color symbolism establishing the three stages of Woman is retained, the familiar contrast of light, dark, and red is applied casually and without sequential logic from one to the other. The spreading of symbolic attributes from a single figure to couples also blunts the allegorical edge and lessens the force of the leitmotif. Even the midnight sun, which as before falls upon the waves, casts a dotted reflection, favoring a naturalistic rather than an emblematic reading of this insistently recurring image.

The turn from a heroic to a lyric mood, as exemplified by the contrast between the two works, occurs after Munch has reached the low point of psychic resistance and after the vitality of the *Frieze of Life* cycle was spent. The force of Munch's symbolic expressions seems to recede, while the formerly charged scenes and personages linger on in a lighter mood.

VILLAGE STREET

Painted 1905–37. Oil on canvas, 39½×41⅜"
Munch-museet, Oslo

If you throw a stone at a group of boys, they will run apart.—A regrouping, an action, takes place.—That is a composition.—To represent the regrouping by means of colors, lines and areas is one of the motives of art, of painting.—

In the middle of the first decade of the new century Munch experienced a deep psychic crisis that resulted in a nervous breakdown in 1908. During the intervening years we witness an attempt at disengagement from the obsessive preoccupations that had shaped the *Frieze of Life.*

Village Street is among the first paintings in which a distinctly new mood emerges—one born of the conflict between the old dreams and a yearning for a new, more external grasp on life. The scene is set in Bad Elgersburg, near Weimar, where Munch spent the

last months of 1905 after particularly heavy travel. His readiness to leave behind the familiar grounds of Aasgaardstrand and to absorb a hitherto unexplored scenery is in itself an indication of a need for a change.

Munch started to paint *Village Street* in 1905, but there is visual evidence that he finished an important portion about 1912, and according to his own testimony he worked on the canvas as late as 1937. While the separation of the sexes, the characteristic physiognomies, and the corresponding color scheme of the central grouping relate clearly to his Symbolist Expressionist phase, which dominated his painting until 1902, the sketchy outline of a boy's figure along the right picture margin is an unprecedented feature in Munch's work. Nor has he previously painted as clear an accent as the scarlet figure of the girl who is superimposed upon the tight, dark circle of her companions. Facing us, she seems ready to detach herself from the group, as if to bring into clashing contrast her own redness and the equally unrelieved yellow of the three ducks in the right foreground. Munch's expert rendition of fowl is further proof of the piecemeal completion of *Village Street*, for it was only in 1908 that birds and animals aroused his visual interest during repeated visits to the Copenhagen zoo. The ducks in a lithograph dated 1912 (fig. 99) are very close to those attracting the attention of the boys and girls in Elgersburg; 1912 is also the date of *Winter, Kragerø* (colorplate 34), in which a similar light-blue sky with jagged edges set off against white clouds obviously relates closely to this work. The blue sky with the red girl and the yellow ducks completes a triad of primaries—a color chord associated in modern painting with tendencies diametrically opposite to those that made up Munch's nineteenth-century visions.

Figure 99. DUCKS. 1912. Lithograph, 10¼×15¾". (Sch.379)

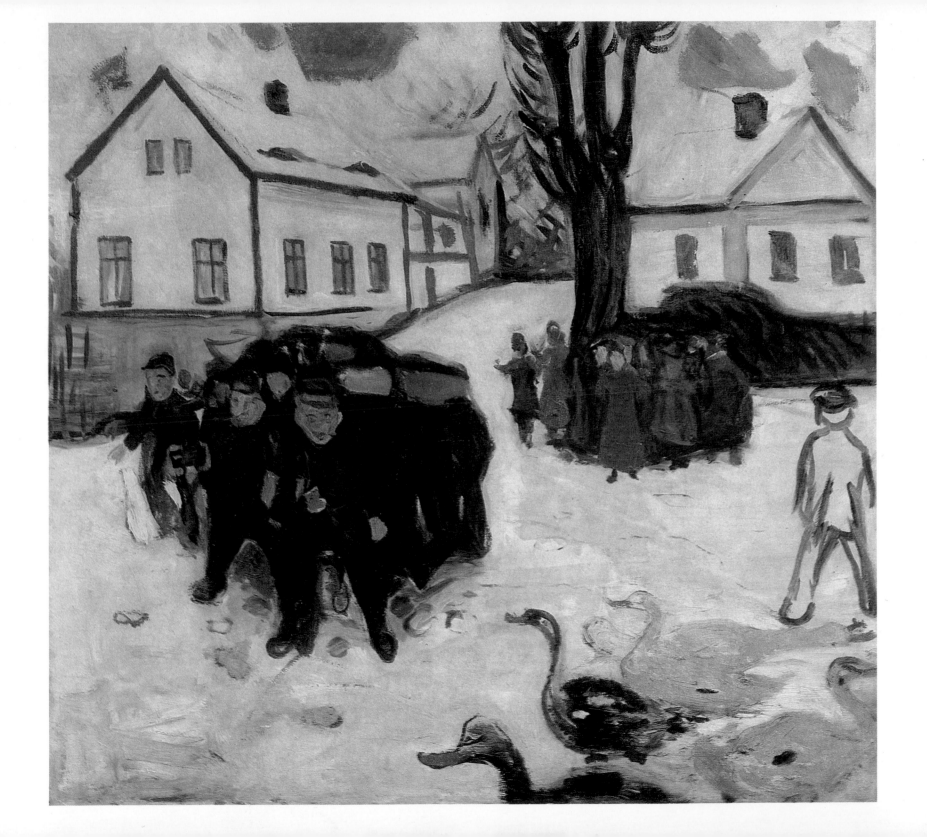

Figure 100.
THE STREET. 1902.
Etching, 7⅛ × 4⅞".
(Sch.150)

SELF-PORTRAIT WITH A WINE BOTTLE

Painted 1906. Oil on canvas, 43½ × 47⅜"

Munch-museet, Oslo

Munch undoubtedly suffered from claustrophobia and from agoraphobia, its twin idiosyncrasy. How else can one explain the frequency of forms in his paintings and prints that suggest an alarmingly expanding space or a threatening convergence? *The Scream* (colorplate 13) and *Girls on the Jetty* (colorplate 23), among many others, or *Galloping Horse* (colorplate 35), the etching titled *The Street* (fig. 100), or the woodcut *The Alley* (fig. 101), to say nothing of *Self-Portrait with a Wine Bottle*, are cases in point. This tortured self-image was painted in Weimar when Munch attended an exhibition of his paintings and prints held at the Grossherzögliches Museum. The seated artist, surrounded by flaming hues, seems to contemplate his own doom. Three distant, almost featureless and half-averted creatures face empty tables that make one think of white-clad coffins. Converging in the distance, these furnishings enclose the victim within an oppressive interior. Munch himself is the painting's oversized and egocentric focus. Everything in the work presses upon him and aims for his exposed

jugular. Unexplainable, except in psycho-symbolic terms, is the oppressive red background shape that frames Munch's head and seems to advance upon him in an ominously engulfing movement.

The deployment of color to suggest states of mind is too consistently observable in Munch's painting to be explained solely as a formal expedient. Whether deliberately or intuitively, Munch, following closely a common musical analogy, identifies pure color with a major key while reserving reduced tonalities for the opposite or minor mood. It also is quite obvious from the viewing of a large number of canvases that for Munch red and green are emotional polarities, the former recurring with high consistency in relation to the sanguinary, transitory nature of man, while the latter stands for the permanent, eternal hues of nature.

Self-Portrait with a Wine Bottle was painted after the shift of emphasis from a charged interior symbolism to a more detached mode of reality observation occurred, but before the nervous breakdown that led to the artist's voluntary confinement in Dr. Jacobson's clinic near Copenhagen. The work, executed in a critical year, may therefore rightly be considered a reflection of Munch's exceedingly tense psychic condition.

left: Figure 101.
THE ALLEY. 1910.
Woodcut, 23⅝ × 19⅜".
(Sch.349)

right: Figure 102.
SELF-PORTRAIT WITH A
WINE BOTTLE. 1925–26.
lithograph, 16½ × 20⅛"

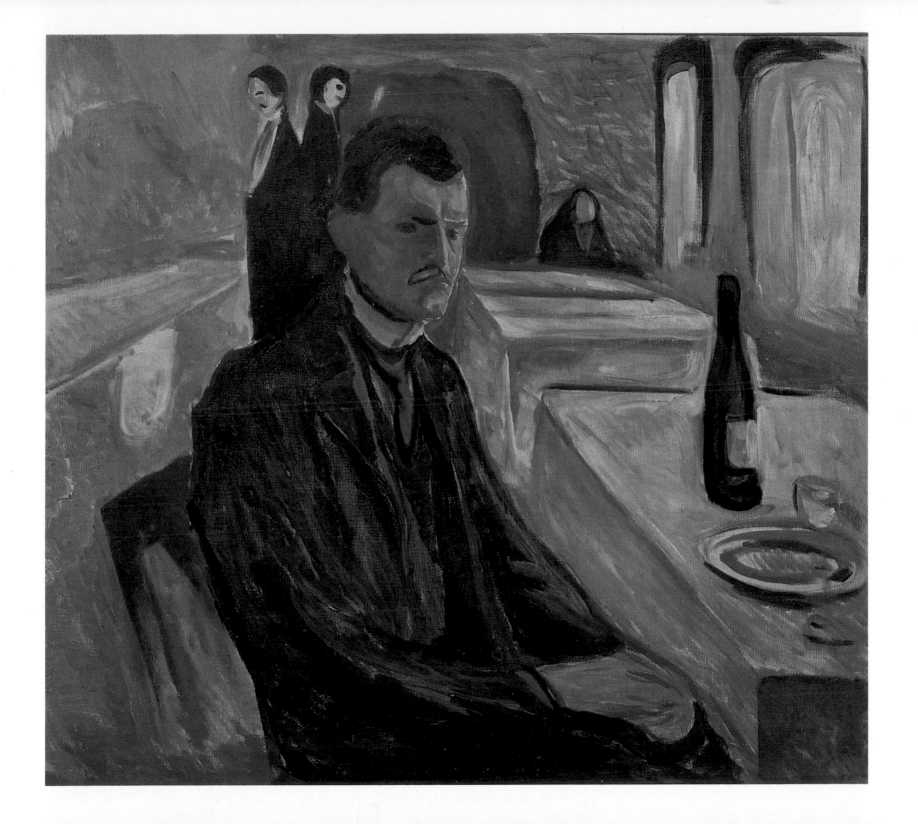

AMOR AND PSYCHE

Painted 1907. Oil on canvas, 47×39"

Munch-museet, Oslo

At the beginning of the century I had the urge to break areas and lines—I felt that this way of painting might become a manner Afterwards I painted a series of pictures with pronounced broad lines of stripes, often a meter in length, running vertically, horizontally or diagonally.

Munch named or allowed his works to be named by others, without attaching much importance to an act that followed rather than preceded the essential creative phase. If, therefore, the reference to classical mythology may be considered incidental, the title is nevertheless in accord with Munch's penchant for the language of love and his concern with amorous relationships.

Amor and Psyche thus confront each other in appropriately classical serenity, in which chasteness and nudity are parallel rather than contradictory attributes. The sensuousness of the encounter is subtly indicated, however, as the darker male figure bends forward toward the woman whose lighter, closed features absorb the male advance.

The airy surface created through straight, thick, downward brushstrokes is a characteristic mark of Munch's short-lived phase during the years immediately surrounding the nervous collapse of 1908. The Munch-museet's large version of *Marat's Death* and *Self-Portrait in a Blue Suit* (colorplate 32)—the former of the same year, the latter following *Amor and Psyche*—are treated in a comparable manner. The section quoted above, from a letter to Jens Thiis, Director of the Nasjonalgalleriet, Oslo, shows that Munch was aware of this distinctive departure in his work.

Amor and Psyche is of interest also as a point of equilibrium in the battle of the sexes as this reflects itself in the artist's imagery. No longer is man subdued and crushed by the power of femininity as he was in the Vampire themes of the 1890s (figs. 52–54). Nor has he, on the other hand, assumed the confident posture of the proudly masculine bathers or of the marching workers—a bearing rendered in relation to woman most explicitly in two late bronzes at the Munch-museet in which male power brutally crushes a now enfeebled and submissive feminine victim. Avoiding triumph or humiliation, *Amor and Psyche* expresses a balanced partnership that is in keeping with a newly emerging, tempered, and positive sentiment.

COLORPLATE 31

PORTRAIT OF DR. DANIEL JACOBSON

Painted 1909. Oil on canvas, 80½ × 43⅞″

Munch-museet, Oslo

I placed him large and with legs apart in the fire of all the colors of hell.... There he begged for mercy and became tame as a dove.

This portrait of Dr. Jacobson is one of Munch's characteristic large standing male portraits of the first decade of the new century. The doctor was in charge of the clinic near Copenhagen to which Munch committed himself as the result of a nervous breakdown in 1908.

Medical authority, personified by the doctor, stands before Munch larger than life. Feet planted, arms akimbo, with an expression matching the arrogant self-confidence of the posture, Dr. Jacobson will evidently stand for no nonsense and is thus depicted by his patient. With unfailing instinct, Munch finds the right pictorial analogy through which to convey a psychological insight. Dr. Jacobson is seen through a veritable color rain, brushed, streaked, and dripped upon the surface with an Expressionist bravado equaled only in Munch's great *Self-Portrait* of 1895 (colorplate 19). Like this earlier

work, Dr. Jacobson's portrait creates intimations of hell through flamelike color that engulfs his shadow and licks at his feet.

The doctor's small, handsome head, satanic features, and full, symmetrical beard already appear in a black-and-white lithograph (fig. 103) completed in preparation for the large oil.

Figure 103. PORTRAIT OF DR. JACOBSON. 1908–9.
Lithograph, 20¼ × 11½″. (Sch.273)

Figure 104.
AT DR. JACOBSON'S CLINIC. 1908–9.
Ink, 5¼ × 8¼″. *Munch-museet, Oslo.*
Munch inscribed the drawing:
Professor Jacobson electrifies
the famous painter Munch and
induces male positive and female negative
power in his enfeebled brain

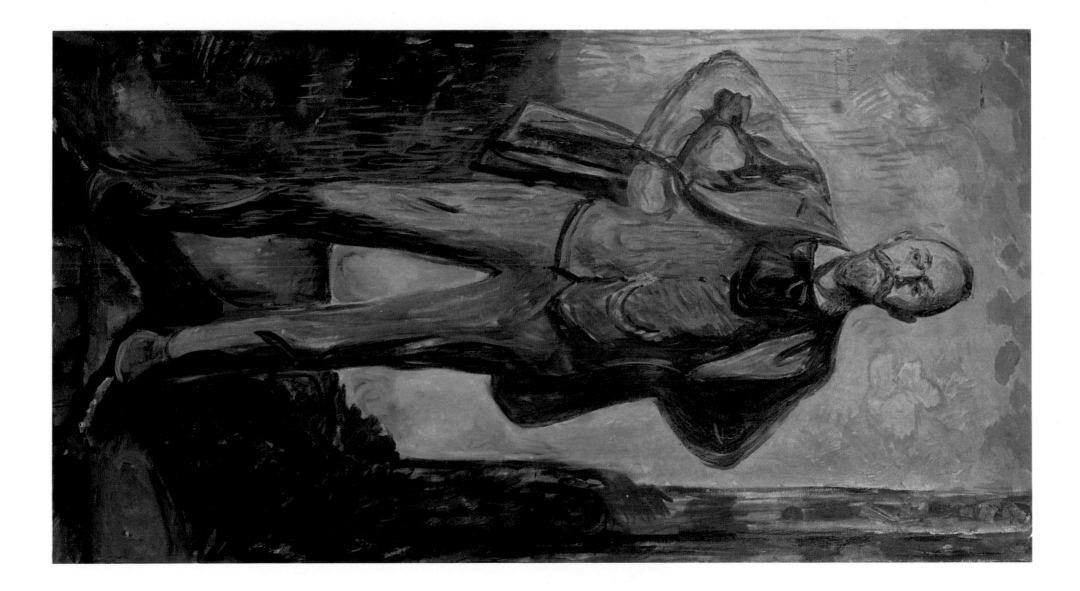

SELF-PORTRAIT IN A BLUE SUIT

Painted 1909. Oil on canvas, 39½ × 43½"
Rasmus Meyers Samlinger, Bergen

Self-Portrait in a Blue Suit affords obvious contrasts to the *Self-Portrait with a Wine Bottle* of 1906 (colorplate 29). It is between the execution of these two works, in the fall of 1908, that Munch suffered a nervous breakdown and entered the clinic of Dr. Daniel Jacobson in Copenhagen.

Painted when he was still under treatment, the more recent oil reflects a rising zest for life and a new interest in external reality. Munch is seated somewhat rigidly in a bright and sunny room. Well dressed and clean shaven, he seems healthy and more composed than he was in his mustachioed dejection a few years before. Two formal devices, both outside the artist's earlier repertoire, are instrumental in creating the new look in Munch's work of that period. They are, first, reliance upon an axial order with horizontals and verticals largely supplanting free form and, second, the use of pure colors and through them an easily legible relationship between advancing and receding picture planes. Instead of the toned-down mixtures that have predominated in Munch's earlier palette, primary colors now assert themselves while green, orange, and pink hues in relatively pure states provide an enriching complement. Pigment is applied in long, sometimes heavy and parallel brushstrokes, with much white between them to create an airy, vibrant surface. More than in any previous work, Munch's interest in transforming retinal perceptions seems to replace his earlier conceptualizations.

Three years later Munch returned to the 1909 likeness in a lithograph in which the same structural concerns result in a stone-hewn quality (fig. 105).

Figure 105. SELF-PORTRAIT. 1912. Lithograph, 12¼ × 10¾". (Sch.358)

COLORPLATE 33

THE SUN

Painted 1909–11. Oil on canvas, 14'10" × 25'10¼"
Aula, Oslo University

Up toward the light

As in the images of the *Frieze*, the sun pierces the sea, but now its radiant circle dominates the penetrating elongation, shaped like the Greek letter TAU, which here sinks into the waters heavily as if it were poured of white lead. Illuminated by the sunrays are the waters of the ocean, the bare rocks of a Northern landscape, and a slim strip of verdant green that separates land and sea. A clean, straight horizon line divides the waters from the sky. The great sun is all-pervasive, shining from the heavens upon land and sea, its rays reaching out to all eternity. Inhuman itself, it is the source of all life.

The Sun is perhaps the greatest achievement of modern mural painting. Symmetrically structured, it occupies the enormous front space of Oslo University's assembly hall, dominating through size, unmitigated frontality, and power of imagery. Its singleness and centrality contrast with the five complementary pairs of mural paintings in the same room (figs. 22–28), and its essentially abstract symbolism opposes the thematic allegory suggested in them. Its uninhabited nature, too, stands in juxtaposition with the peopled episodes of the other walls.

Munch extended the sun image in this mural from a partial to an embracing role, having first proposed a Nietzschean Mountain of Man that rose toward a sun-covered sky (fig. 107). Upon further reflection, and in compliance with advice from friends, he abandoned the problematical symbol to retain the sun image in pure, intense, and masculine dominance.

left: Figure 106. TOWARD THE LIGHT. C.1914–16.
Color lithograph, 38⅛ × 27¾

below: Figure 107. MOUNTAIN OF MANKIND WITH ZARATHUSTRA'S SUN. 1910.
Oil on canvas, 29⅞ × 49⅝" . *Munch-museet, Oslo.*
(Sketch of subject originally intended for centerpiece of Aula murals.)

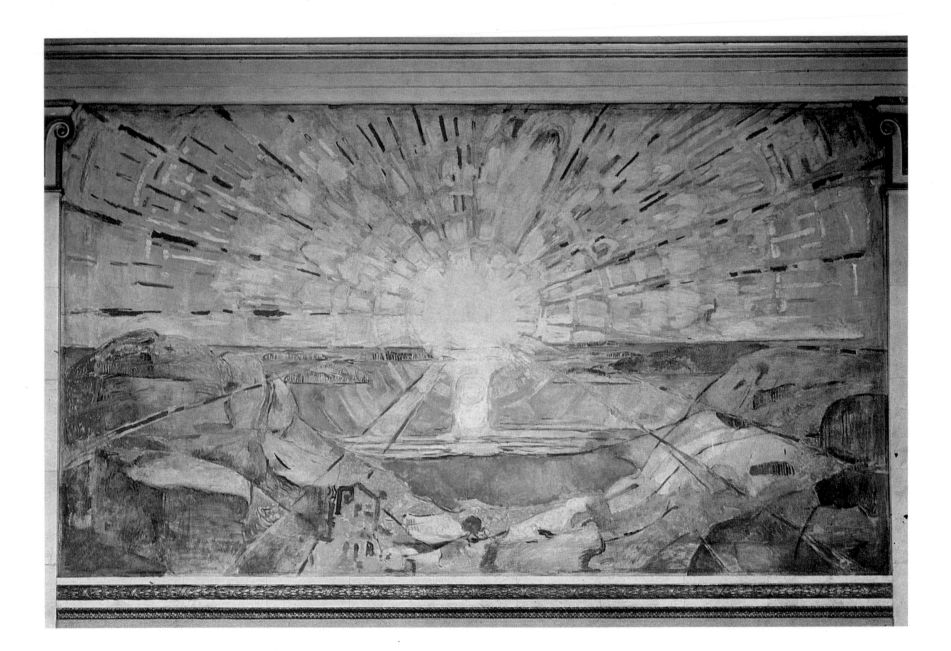

WINTER, KRAGERØ

Painted 1912. Oil on canvas, 52 × 51½"
Munch-museet, Oslo

Norway, whither I shall surely return one day, for her natural beauty is important enough for my art.

In 1909 Munch left Dr. Jacobson's nerve clinic in Denmark to return to Norway. Avoiding memory-laden Oslo and the scenery at Aasgaardstrand, he rented the Skrubben estate at Kragerø to lead a life of the utmost simplicity, and to divorce himself as far as possible from the emotional strains that had caused his collapse. It can hardly be considered accidental that, in this moment of inner consolidation, the structural component of his art should come to the fore. The artist's efforts to substitute a reflection of palpable reality for the imagery that sprang from acute emotional states obviously depended on a more systematic, less spontaneous approach.

Winter, Kragerø is a calmly constructed painting in which color is held within a narrow range to cede primacy to an intricate architectural form. The almost exclusive reliance on cool tonalities is a new departure for Munch. Touches of green, yellow, red, and violet tones act as reminders of his former color schemes, but the dominance of the recently established range from icy white to ultramarine now accompanies the emergence of a linear, geometric understructure.

In this chill, bright landscape Munch pays close attention to true scale and constructs his intricately related levels with relentless visual logic. The roof motif in the foreground, used toward similar ends in the *Harbor of Lübeck* of 1907, again serves to indicate the painter's vantage point. The prominent form recedes diagonally, allowing the eye to glide past its angular outlines. It is as though the Post-Impressionist master, whose eyes had been opened almost a quarter-century before to the sensibilities of Van Gogh and Gauguin, were reaching out in his Kragerø phase for the complementary insight that constitutes the legacy of Paul Cézanne.

Munch returned to this motif in a painting at the Kunsthaus in Zurich, dated 1925–31. Although beautifully painted, the later work, like so many of his re-creations, lacks the freshness and convincing structural firmness of the 1912 version.

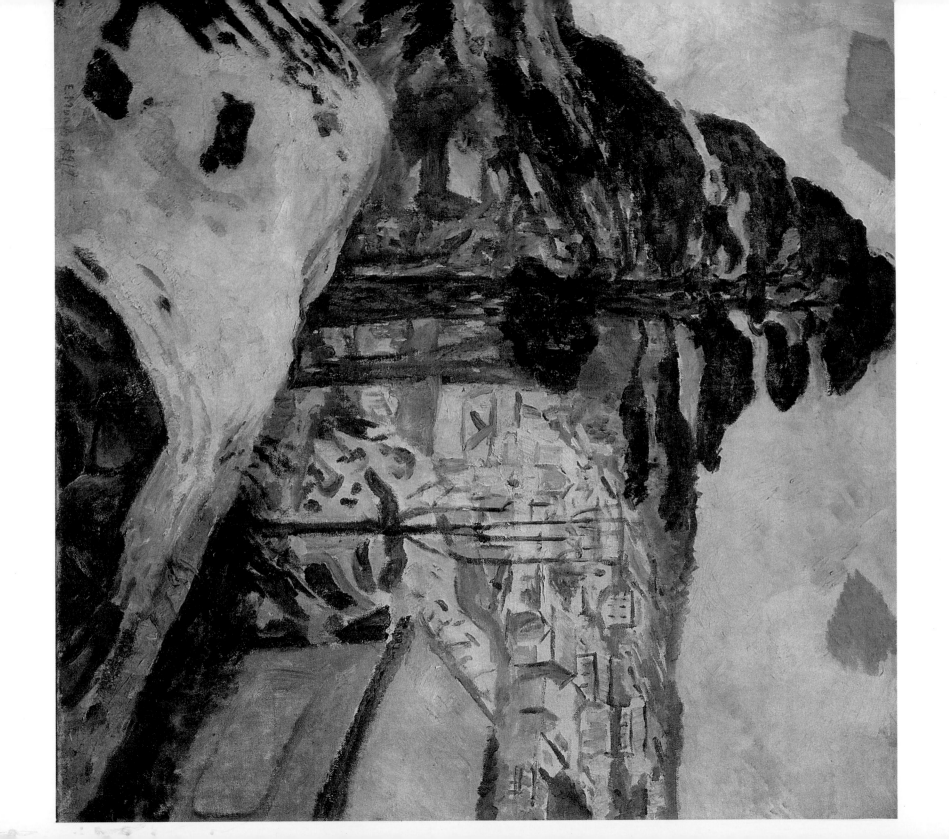

GALLOPING HORSE

Painted 1912. *Oil on canvas,* 58¼ × 47"

Munch-museet, Oslo

A horse-drawn sleigh speeds down a narrow, wintry road—the same hollow passage that Munch uses so consistently as a symbol of confinement. Two men and two girls, in characteristic separation from each other, stand aside in helpless passivity or cling, terror stricken, to the surrounding rocks. The smallish figure of the driver contrasts with the powerful hulk of the animal, as if to stress the frailty of the rational component in relation to overpowering elemental forces. The focus of this work, however, is the horse's large, panic-filled eye, turned toward us in mute terror.

Symbolic color strengthens the anxiety theme that Munch here transfers to a new context. Brown, heightened toward red, ever associated in Munch's work with sanguinary animality, contrasts with the cool blueness of guiding man. The frightened girls cling to their green safety, which forms a color oasis among the cold white and blue of snow and rocks that depict the solid, tactile reality of the Kragerø landscape.

Galloping Horse is also the subject of one of Munch's finest later etchings (fig. 108). As in earlier times, the artist returns to the print medium to repeat in simplified form a theme originally executed on canvas. Apart from the reversal through the printing process, the subject remains unaltered. Every detail of the original version is accounted for in the print completed three years later. The effect of intensification is achieved through subtle adjustments in scale which increase the contrast between horse and rider by confining the speeding animal within a reduced space.

Set in a new landscape, *Galloping Horse* also alters the nature of Munch's symbolic content. Instead of centering on the grand love and death themes of the *Frieze,* the work hints at the tensions between uncontrollable urges and rational restraints—a polarity that for the recently recovered artist must have had more than allegorical significance.

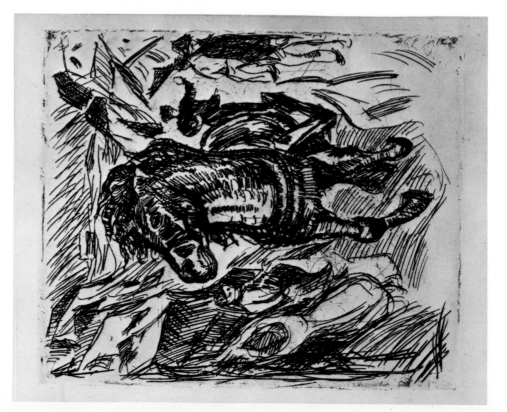

Figure 108. GALLOPING HORSE. 1915. Etching, 15 × 12¾". (Sch.431)

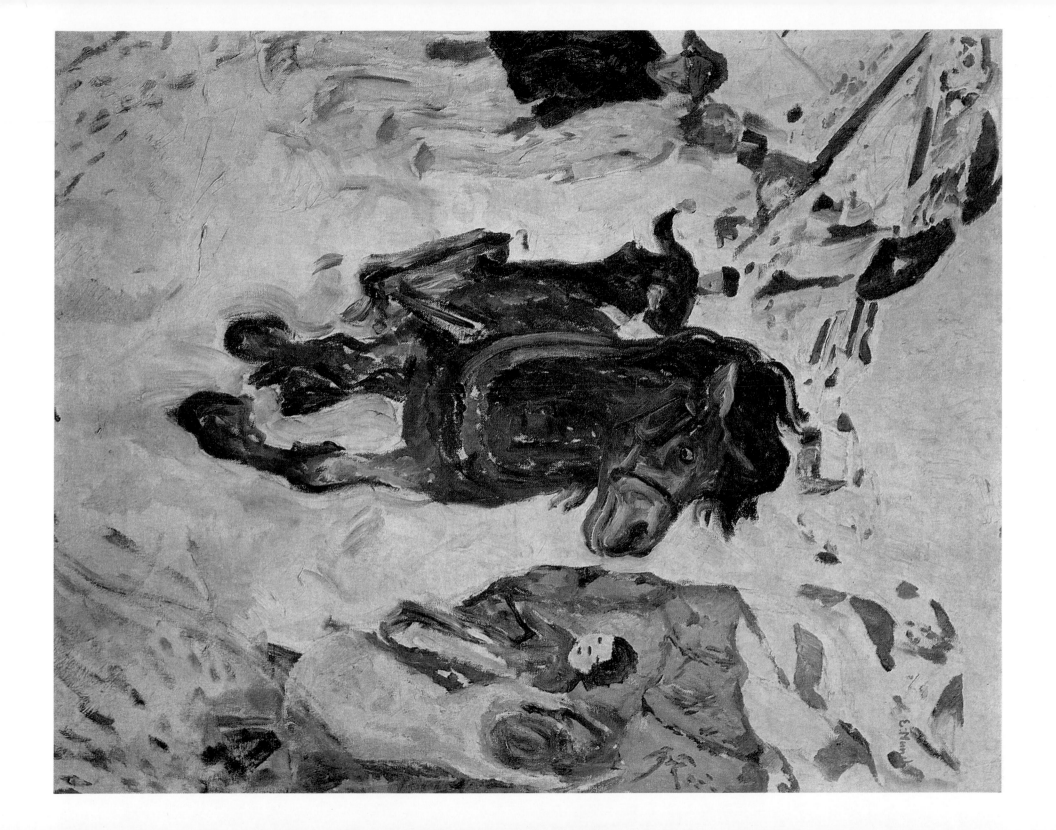

WORKMEN ON
THEIR WAY HOME

Painted 1915. Oil on canvas, 79½ × 89½"
Munch-museet, Oslo

Now is the time of the workers—I wonder whether art will not again become the possession of everyone?—and again get its place in public buildings on large wall surfaces.

—letter to Ragnar Hoppe,
February, 1929

After the completion of the Aula murals, Munch began to think in terms of a series in praise of the working man. He made numerous drawings and prints simultaneously extolling Worker and Man, the latter now freed from sexual preoccupations (figs. 109, 110). The charcoal drawing (fig. 111) of snow shovelers was conceived as a mural study during the last period of Munch's life, when he still hoped for a commission to execute the series in Oslo's City Hall.

In one of Munch's most vital canvases a collective,

forward-striving male energy assumes social significance if one reads it as a glorification of the urban proletariat—an interpretation certainly not alien to the artist's thinking. Aggressive strength marks the features of the central marchers who, as if coming down upon us, push the pavement behind them with long strides. The sense of motion is enhanced by a curious transparency of the legs that contrasts with the dark, broad-shouldered upper parts of the workmen. The long street is still in evidence, but man is no longer devoured by it. He seems, on the contrary, to have conquered the vacuum through sheer numbers and the force of a motion that makes him, rather than the emptiness, the dominant factor. Brightly colored house façades in red, blue, and green stand in effective juxtaposition against the monotonous uniformity of the human stream.

Figure 109.
SNOW SHOVELERS.
1911. Woodcut,
23⅝ × 19½".
(Sch. 350)

left: Figure 110. SNOW SHOVELERS. 1912.
Lithograph and woodcut, 25½ × 20⅛". (Sch.385/b)

below: Figure 111. SHOVELING SNOW. c.1936.
Charcoal, 10⅞ × 23". *Munch-museet, Oslo*

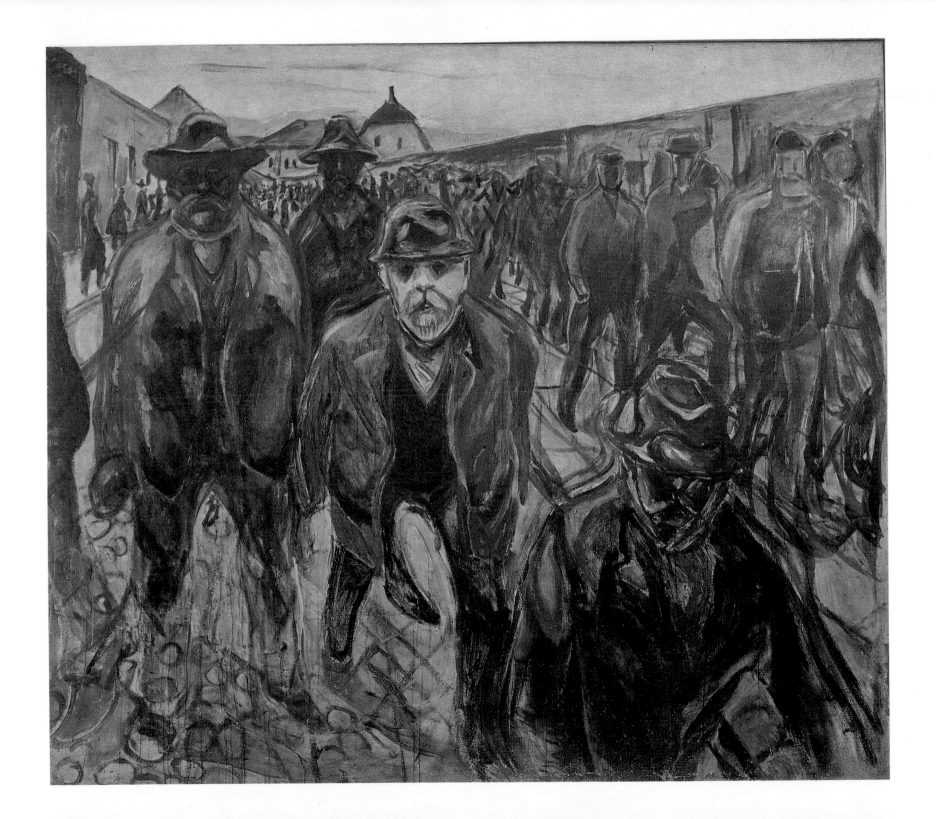

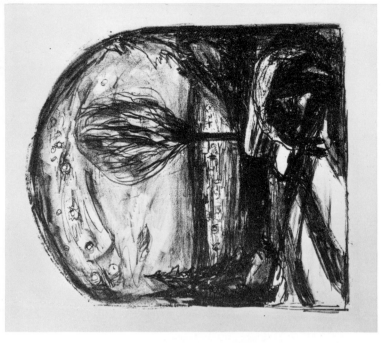

COLORPLATE 38

STARRY NIGHT

Painted 1923–24. Oil on canvas, $47\frac{1}{2} \times 39\frac{3}{8}''$
Munch-museet, Oslo

Now it is shadows and movements. . . Such shadows as the prisoner sees in his cell, those curious gray streaks of shadow which flee and then return, which slide apart and come together again like fans, bending, curving, dividing.

Munch's art prior to 1909 was generated primarily by intense psychic pressures, from which he sought to retreat in the subsequent decade through a deliberate turn toward a palpable reality. Thereafter, in the last twenty years of his life, these two opposing attitudes were brought into dialectical consonance. In this large version of *Starry Night* the aging Munch reaches back for an old motif, which he now re-creates in terms of recent awarenesses.

The invisible presence of man casts long shadows on a Northern scene in late evening glow. Unlike Munch's Kragerø landscapes of a decade before, in which he recorded the stark beauty of untamed nature, *Starry*

Night is replete with human content. The setting midnight sun illuminates a distant village, while in the already darkened middle ground a warm light from a hidden window shines through the tree-covered scene. Mysterious shadows, made eerier than ever by their contrast with the serene landscape conception, dance in the picture foreground. They bring back not only the outlines of lovers subsumed in the *Starry Night* landscape of 1893 (colorplate 15), but also the heavy shadow images in *Puberty* (colorplate 11), the implausible reflections in *Moonlight* (colorplate 12), and many other such shaded accents that are present throughout the Norwegian's pictorial vocabulary.

Starry Night is prefigured in an identically named lithograph of about 1920 and a drawing of 1923 (figs. 112, 113). The three works have in common the minuscule treatment of the distant houses through which the enveloping majesty of the Northern night comes into its own. All hint at mysterious doings in the foreground—strange shadows in the drawing, an arched figure on the bench in the lithograph, and a sharp male profile subterraneously positioned in the canvas—that create an agitated tenseness amidst the prevailing serenity. Finally, a common form in the three works is recognized in the archlike structure that gradually transfers itself from the framing canopy in the print to the trees and hedges of the painting.

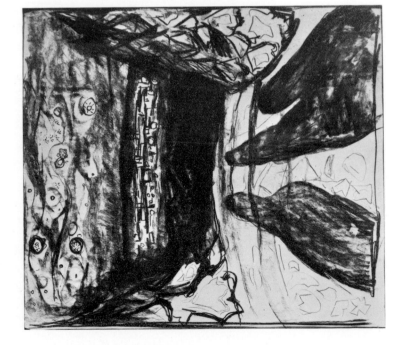

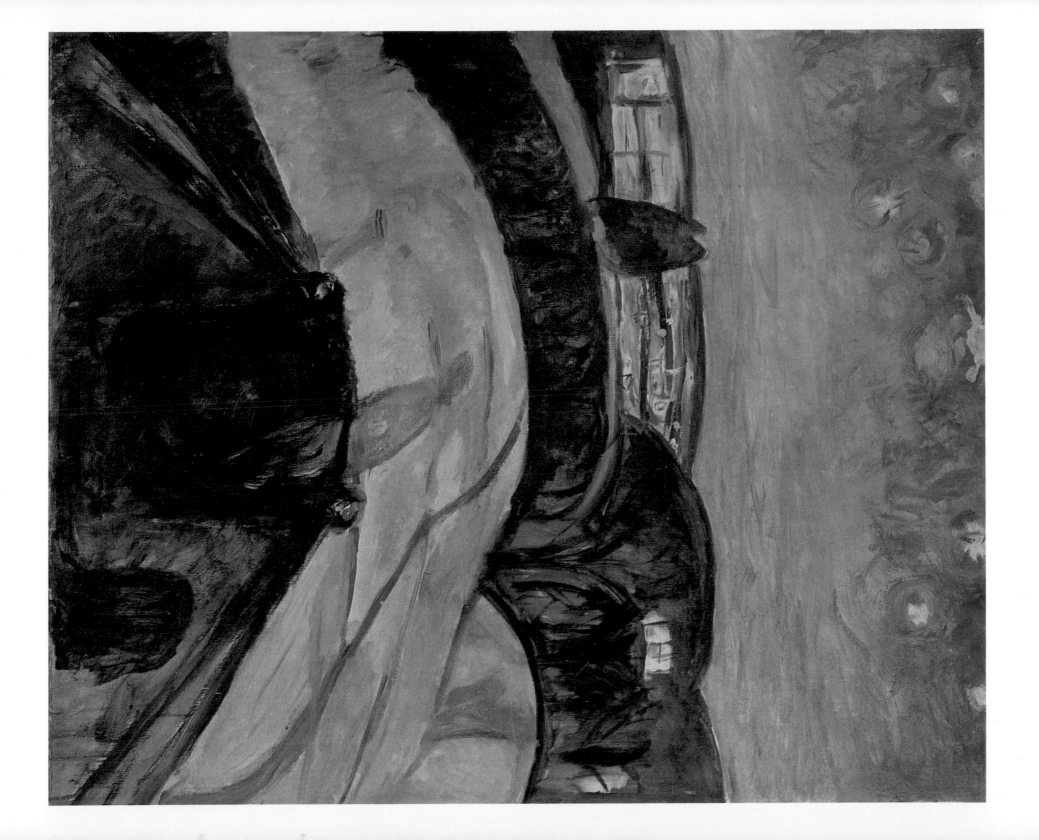

Figure 114. MODEL STUDY. 1925. Ink, 6¾×9″. *Munch-museet, Oslo*

SEATED MODEL

Painted 1925–28. Oil on canvas, 53¾×45½″
Munch-museet, Oslo

The last among recurrent feminine images in Munch's work is that of the model Birgitte Olsen, who is referred to at times as the "Gothic Maiden." Her distinct features appear in *Ordeal by Fire*, one of a series of woodcuts based on Ibsen's *Pretenders*, and in other woodcuts dated 1930 or 1931 (figs. 115, 116). All render the fine features and somewhat flat-chested, angular elegance of the young woman who inhabited the artist's pictorial world during this late phase, much as Inger Munch or Eva Mudocci did before.

This large and superbly executed oil, alternately titled *On the Sofa*, is the key work among Birgitte portrayals. Although dressed rather than nude, the figure has a family resemblance with earlier, similarly positioned subjects. The motif goes back to Munch's early *Girl Sitting on a Bed* of 1884 and is renewed first in

Puberty (colorplate 11) and subsequently in *Girl Seated on the Edge of Her Bed*, 1915–16. In this work, however, the model no longer clings anxiously to an edge but is firmly placed in the center of the sofa. While she relaxes in a graceful half-turn, earlier models held their arms together in cramplike protective gestures. The cool colors, ranging from gray-green to lavender, complete the evident contrast between the model's objective manner and the strained renditions of comparable subjects in earlier times. Through its emotional detachment and the relaxed bravura of execution the work takes its place within the great portrait tradition of Velázquez and Van Dyck.

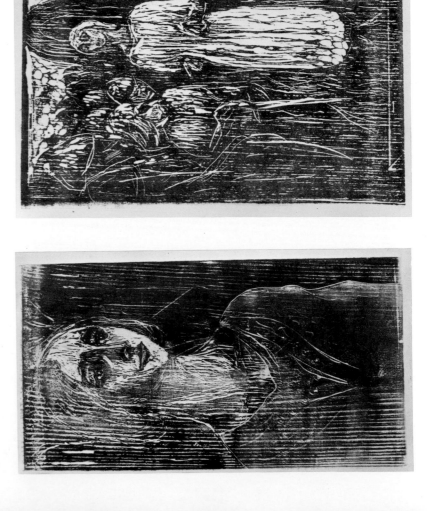

far left: Figure 115. BIRGITTE, THE GOTHIC GIRL. c.1931. Color woodcut, 23⅝×12½″

left: Figure 116. ORDEAL BY FIRE, ILLUSTRATION FOR "THE PRETENDERS." c.1927–31. Woodcut, 18⅛×14¾″

Figure 117.
SELF-PORTRAIT,
BERGEN. 1916.
Oil on canvas,
35 3/8 × 23 5/8".
*Munch-museet,
Oslo*

"BETWEEN CLOCK AND BED"
SELF-PORTRAIT

Painted 1940–42. *Oil on canvas,* 58 3/4 × 47 1/2"
Munch-museet, Oslo

As in Ibsen's When We Dead Awaken *the sculptor's work of resurrection remained unfinished, so it was with my work also.*

Munch drew and painted himself as frequently as ever in his old age, probing still more deeply within his features as if in search of answers that only they could furnish. As is the way with old masters, he saw himself increasingly as another person and paradoxically attained thereby a heightened self-knowledge.

A troubled half-profile of 1916 shows his anxiously darkened face in front of a window, as if undecided whether to sustain a posture pointing within or to turn outward to the cheerful city of Bergen (fig. 117). Ten years later the *Self-Portrait in Ekely* (fig. 118) is carried out in the firmly structured cool tonalities that mark the climax of his striving for chastened expression. As in the related *Self-Portrait with Palette* of the same year, Munch's now aging face is free from the shadows that had pressed to the surface in previous self-renditions. A healing green all but displaces its ominous red complement. The shadows, however, return in a self-por-

trait of 1942 titled *By the Window,* in which Munch stands with his back to a snow-covered forest as a deep-red hue crosses features that register dejection, defiance, and despair (fig. 119).

Between Clock and Bed is Munch's last summarizing masterpiece. The artist, in his late seventies, stands among his paintings in unself-conscious frontality, knees slightly bent, shoulders stooped. A softly projected symbolism is inherent in the painter's pensive posture before a closed and an open door, as if some final alternative remained to be considered. The bed-spread to his left, raised from its prosaic existence to sublime radiance, darkens by its own intensity the tall, sinister clock that shows no time. Worked in loose, liquid brushstrokes, this relaxed self-portrait achieves an unsurpassed degree of consonance between outward and inner visions, objective and symbolic content, graver and lighter states of mind.

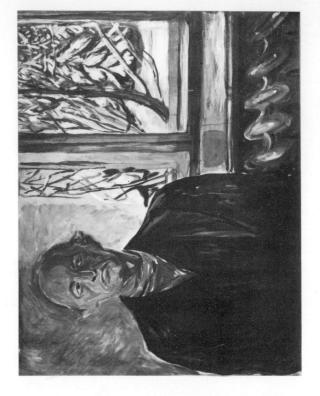

below: Figure 119. BY THE WINDOW,
SELF-PORTRAIT. 1942. Oil on canvas,
37 3/8 × 43 1/4". *Munch-museet, Oslo*

left: Figure 118. SELF-PORTRAIT,
EKELY. 1926. Oil on canvas,
36 1/4 × 28 3/4". *Munch-museet, Oslo*